THE
ALA STORY
COLLECTION
OF INTERNATIONAL
MODERN ART

SANTA BARBARA MUSEUM OF ART
SANTA BARBARA, CALIFORNIA

ALA STORY

DIRECTOR 1952 TO 1957
SANTA BARBARA MUSEUM OF ART

Cover: WILLIAM DOLE, *Ala's Story*, 1971

This project was supported in part by a grant from the National Endowment for the Arts, a Federal agency.

Catalogue designed by Shelley Ruston

Photography by Hal Clason, Margaret Mallory, Wayne McCall and Karl Obert

Text—Andover by The Composition House
Display—Michelangelo by Lettergraphics
Printed in an edition of 3000 by Haagen Printing

Published by the Santa Barbara Museum of Art
1130 State Street
Santa Barbara, California 93101

Library of Congress Cataloging in Publication Data

Santa Barbara Museum of Art.
 The Ala Story Collection of International Modern Art.

 Version of: The Ala Story Collection of the Santa Barbara Museum of Art. 1971.

 1. Story, Ala—Art collections—Catalogs. 2. Art, Modern—20th century—Catalogs. 3. Art—California— Santa Barbara—Catalogs. 4. Santa Barbara Museum of Art—Catalogs. I. Santa Barbara Museum of Art. Ala Story Collection of the Santa Barbara Museum of Art. II. Title.
N6487.S25S24 1984 760′.09′04074019491 84-27552
ISBN 0-89951-056-6

CONTENTS

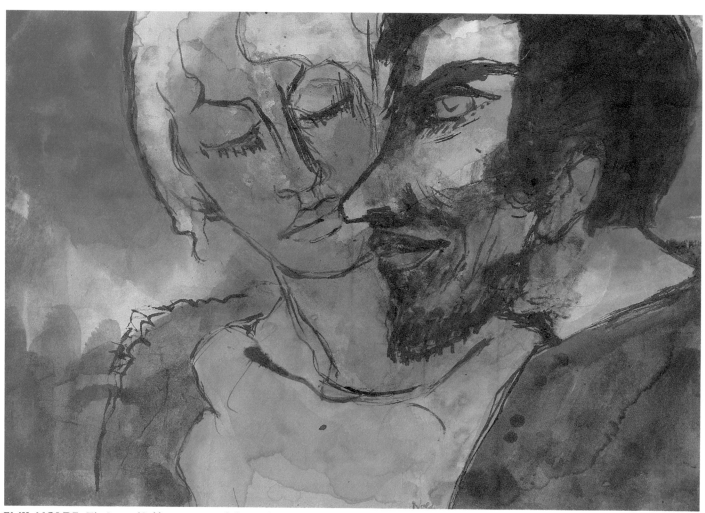

EMIL NOLDE, *The Lovers* (Self-portrait with his wife, Ada), 1932

FOREWORD

How does one define the personality of a museum? It certainly cannot be described in terms of architecture, collections, or programs alone, although each is an important contributing factor. The key is the word "personality": ultimately an institution's profile is defined by people, people who have worked for, contributed and donated to, thought about, and, yes, even argued and disagreed about its architecture, its collections and its programs. The unique persona of the Santa Barbara Museum of Art is the result of a fertile mix of ideas and deeds put forth by creative and dedicated individuals over the past four decades. Some of these individuals, through their taste, talent, and espirit, have left an enduring imprint on the Museum.

Such a person was Ala Story. As successor to Donald Bear, founding director of the Museum, Mrs. Story took on the formidable challenge set by his pioneering example. Her tenure as Director from 1952 to 1957 was relatively brief, but her cosmopolitan and civilized sensibility lives on, embodied in so many of the Museum's continuing aspirations. Her belief in the important place of art and artists in the life of the community and her dedication to the idea of "museum" was the leitmotif of her life before, during and after her directorship. In recognition of this, the Ala Story Collection was formed during her lifetime and celebrated with an exhibition in 1971.

Now, more than a decade since the formation of the collection, we pay homage to the memory of Ala Story with the dedication of the Ala Story Gallery of International Modern Art in the newly renovated spaces of the Museum. Since the publication of the first catalogue of the Ala Story Collection in June 1971, on the occasion of the Museum's thirtieth anniversary, there have been many changes in the collection. Works have been added, others promised as gifts, still others selectively deaccessioned. Therefore, it seemed appropriate to mark the special installation of the Ala Story Collection in its new home with the publication of a new catalogue.

The period covered by the term "international modern art" spans the first seventy years of this century and includes such diverse styles as Post-Impressionism, Fauvism, Cubism, German Expressionism, Constructivism, Futurism, Dada, Surrealism, as well as Vorticism, Synchronism, and Abstract Expressionism. The Ala Story Collection is a wide-ranging one reflecting the refined tastes of its namesake. An astute art lover can, of course, find many historical links among the parade of styles included in this growing collection, but the unifying factor is, above all, quality.

Over the years, many generous donors have presented art works in memory of Ala Story, works in keeping with her spirit, to form a significant resource which—like the Preston Morton Collection and the Wright Ludington Collection—presents a compre-

hensive record of an important era in the cultural history of mankind. One very special donor saw the need for a permanent home for this collection, a place where this resource can be used in many ways, and by her generosity made it possible. The only stipulation governing the use of the Ala Story Gallery of International Modern Art is that the Ala Story Collection, or major selections from it, be hung for a minimum of three months each year. For the remainder of the year, the gallery will be used for other collections or exhibitions of international modern art, or for comparative exhibitions involving works from the Ala Story Collection.

More than ever before, the words written in 1971 by Paul C. Mills, then Director of the Museum, hold true: "The Story Collection has its own aura, its own personality…. May it inspire collectors and friends of the museum to emulate it—may it inspire the museum itself to maintain and advance the sharp eye for quality, the true catholicity of taste it evidences."

Richard Vincent West
Director

ACKNOWLEDGMENTS

This catalogue is not simply a revised and updated version of one published over thirteen years ago. It has been extensively rewritten, with much new material and research incorporated. It could not have been produced without the expertise and assistance of many people, and I should like to thank them here for their contributions.

The Ala Story Collection was brought into being by friends and admirers after she retired as museum director. It was continued after her death when donations were made towards a gallery in her honor. We should thank Margaret Mallory, first and foremost, for pursuing this idea and motivating us into creating at last the gallery and the opening exhibition which allows the public an overall view of Ala Story's direction and taste in art.

Christine Buckingham and Katherine McIver worked with Miss Mallory and the Museum staff in preparing the contents of the catalogue—revising old material, collating new information, and cataloging the numerous promised gifts to the Ala Story Collection. They also took part in developing the new design and format given to this catalogue. The Museum's curatorial staff under the supervision of Chief Curator Robert Henning, Jr., played a large part in this project as well. Special thanks go to Project Director Barry M. Heisler, Assistant Curator for Collections, and Ethel King, Curatorial Assistant, who oversaw the final form of the text and kept track of the multitude of details which make up any such publication. In addition, Mr. Heisler and Registrar Elaine Dietsch have been involved with all aspects of the preparation and selection of the works of art included in the inaugural exhibition of the Ala Story Collection in its new gallery. Paul Prince designed the special opening installation, ably executed by Dean Dawson and his staff.

The final shape, form and quality of the catalogue is the result of the ministrations of Shelley Ruston, Assistant Director for Programs and Publications. To her and to all the others who made possible the successful completion of this project, I extend my appreciation.

The publication of this catalogue was made possible, in part, by a grant from the National Endowment for the Arts, a Federal agency, and by private contributions.

R.V.W

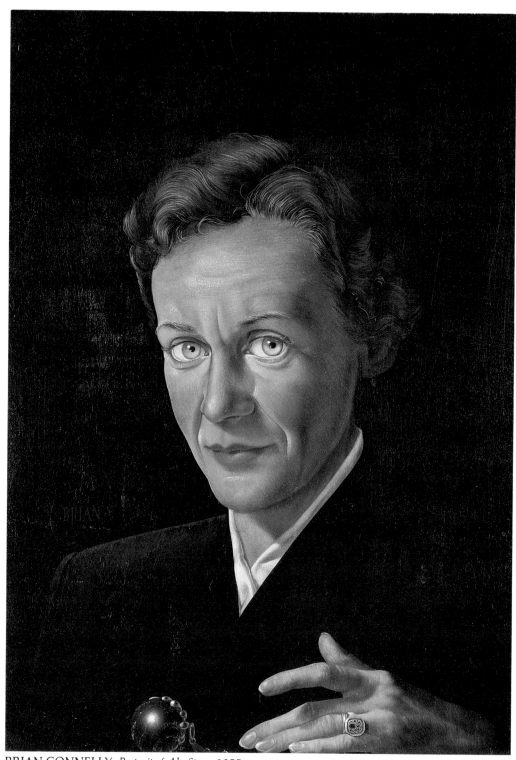

BRIAN CONNELLY, *Portrait of Ala Story*, 1955

ALA STORY
1907-1972

Ala Story, née Emilie Anna Maria Heyszl von Heyszenau, was born in Austria, a descendant of the twelfth century Minnesaenger Hartmann von der Aue on her mother's side. Her father, Commandant of the Uhlans (Cavalry) under Franz Josef, died just before the outbreak of World War I.

Before finishing her formal education, the young noblewoman passed the examination to enter the Academy of Fine Arts in Vienna and studied there for five years as well as two years at the University. When she saw the first retrospective exhibition of Vincent van Gogh, held at the Vienna Secession in 1928, it shattered her illusion of being a creative artist. Her mother reached the decision to send her to London to study English for five months. Enjoying the freedom away from the conventional life of Austria, she made up her mind to stay on in England and to pursue a career in the art world. Her first job in the London Beaux Arts Gallery brought her into contact with renowned London and Paris artists. Still in her teens she organized the first London exhibition of the Wiener Werkstätte (Vienna Arts and Crafts) which was opened by the Austrian Ambassador and drew wide attention. In short succession she became secretary of the Redfern Gallery, then manager of the Wertheim Gallery, and at the age of twenty-five accepted a partnership and directorship of the Storran Gallery—named after herself and Lady Cochran of Cults. When this gallery was successfully established it changed ownership under the condition that Mrs. Story remain as Director. Subsequently she became partner and co-director of the Redfern Gallery, today still one of the best known galleries in London. In 1938 she founded the Stafford Gallery of which she was sole owner.

By 1939 the approaching war had a paralyzing effect on the galleries of London; many did not reopen after the summer. Realizing the difficult straits in which contemporary artists found themselves, she reorganized her gallery and changed its status to a non-profit membership organization, renaming it The British Art Center, in which only group exhibitions of artists at war were held.

This gallery was officially opened by A. P. Herbert in the fall of 1939. Among the first members to join and support this effort were Hugh Walpole, Augustus John, J. B. Priestley, George Bernard Shaw, Jacob Epstein, H. G. Wells and others who were aware of Ala Story's interest in promoting contemporary art. The Honorary Committee of the Art Center included Chester A. Beatty, The Rt. Hon. Earl of Sandwich, Samuel Courtauld and Kenneth Clark. Within a few months the membership exceeded 1400. Elizabeth Hudson, a connoisseur of art who had visited London's art galleries and was impressed with Mrs. Story's dedicated work, arranged for the invitation in

June 1940 (the 'phony war' had not yet ended in England) to assemble a British exhibition of wider scope than had previously been seen in America. It was presented in the Phillips Gallery in Washington, D.C.

After Mrs. Story's arrival in America, the blitz started over London and continuance of The British Art Center became impossible. She established the American British Art Center in New York (which she directed until 1951) under the patronage of honorary committees from Great Britain, Canada and the United States; the latter included among its members Duncan Phillips, Mrs. John D. Rockefeller, Jr., John Nicholas Brown, Hon. Robert Woods Bliss, David Finley (then Director of the National Gallery) and the Rt. Hon. Richard G. Casey, Lord Casey of Berwick, the late Governor General of Australia.

The American British Art Center was opened officially in the fall of 1940 by Sherwood Anderson, Charlie Chaplin and the British Consul General. It was also a nonprofit membership organization with the purpose of introducing British artists to America, and to discover and exhibit young American artists of promise. For the first time, works by English artists such as Henry Moore, John Piper, Graham Sutherland, Paul Nash, Ben Nicholson and many others now internationally known, were shown. Young artists, such as Philip Evergood, Adolph Gottlieb, Franz Kline, Jacques Lipchitz, Seymore Lipton, Robert Motherwell, Mark Rothko, and Ossip Zadkine, were exhibited.

Apart from her work as President and founding Director of the American British Art Center, Ala Story raised funds for the purchase and subsequent donation of British paintings, and secured for that purpose $5,000 from the American Academy of Arts and Letters. Some of the British paintings are now in the collections of the Museum of Modern Art, the Museum of Fine Arts, Boston, and the Phillips Gallery. Ahead of her time, she proved her deep interest in civic problems by organizing in the Art Center the first art auction for the benefit of the National Association for the Advancement of Colored People, as well as several group exhibitions of paintings by members of Local 22 Dressmakers' Union. Proceeds from the Center's last exhibition went to the Damon Runyon Fund; the introduction to the catalog was written by Walter Winchell.

In 1942 Sarkis Katchadourian, who had spent five years in India and Ceylon recreating on his canvases the original paintings in the caves of Ajanta, Bagh, Badami and Sigiriya, presented these facsimiles in the American British Art Center. Some of these were purchased by the Metropolitan Museum of Art and formed part of the first traveling exhibition booked by Donald Bear for the Santa Barbara Museum of Art.

In 1947 Mrs. Story co-founded Falcon Films, Inc., with Margaret Mallory—the first documentary art film company in the United States to produce 16mm films in sound and color. Among the productions are "Henry Moore," with script and narration by James Johnson Sweeney; "French Tapestries Visit America," with script and narration by Meyric Rogers; and "Grandma Moses," with script and narration by Archibald McLeish.

As the second Director of the Santa Barbara Museum of Art (1952-1957), Mrs. Story set the pattern for her activities from the start. Mr. Thomas Carr Howe, Jr., in the introduction to a catalog for Ala Story's and Margaret Mallory's private collection which was shown at the California Palace of the Legion of Honor, wrote: "Back in the early forties, before I came to know her personally, I became 'acquainted' with Ala Story by correspondence. In those days she presided over the American British Art Center in New York...her primary aim was to introduce contemporary British artists to the United States. This she achieved with brilliant success. During the forties Mrs. Story circulated exhibitions among the museums in America, an activity which actually brought me into personal contact with her. Her tireless quest for talent, her imagination, her inventiveness, her boundless energy and her endless enthusiasm made an unforgettable impression. Little did I suspect at that time that in 1952, I would be welcoming her as a colleague on the West Coast...."

Evidence of Ala Story's energy and taste during her five years as Director were the many fine exhibitions held at the Santa Barbara Museum of Art. Herewith a sampling:

Four Painters of Spanish Descent: Picasso, Gris, Miro, Dali, 1953 (The first Fiesta exhibition)
Leonardo de Vinci: Models of Invention, 1953
Marsden Hartley, 1953
Paintings and Graphics of Marc Chagall, 1953
The Graphic Art of Käthe Kollwitz, 1953
Designs for Fountains, 1954
Impressionism and Its Influence on American Art, 1954
Twentieth-Century Sculpture, 1954
The School of New York, 1954
The Horse in Art: Paintings—17th-20th Century, 1954
Paintings by Oskar Kokoschka, 1954
Paintings of Georges Rouault, 1954
Paintings of Max Beckmann, 1954
Paintings and Watercolors by Paul Signac, 1954
Watercolors and Paintings by Paul Klee, 1955
Auguste Rodin, 1955
An Eighteenth Century Chinese Red Lacquer Room (purchased by the Cleveland Museum of Art), 1956
Illusion and Reality, 1956
Paintings from the Gertrude Stein Collection, 1956

Another activity which she instigated was "Picture of the Month" for which she selected a picture for exhibition in the Museum and wrote about it in the *Santa Barbara News Press.*

In 1955, Mrs. Story created the *Pacific Coast Biennial* which concentrated on the states of Washington, Oregon and California. Art critic Henry Seldis considered it to be "the most significant project initiated under her administration. There has never been a competitive exhibition of contemporary paintings from the entire Pacific Coast

area...Therefore, the *First Pacific Coast Biennial* of the Santa Barbara Museum of Art takes on far more than regional importance. In the light of the growing recognition of this region, the ambitious Santa Barbara Project has national and even international significance...." In 1957, upon Ala Story's resignation as Director of the Santa Barbara Museum of Art, Seldis wrote:

> Ala Story's resignation as Art Museum Director here came as an unwelcome surprise to the community. Not only did she plan and supervise the large number of exhibitions the museum has offered residents and tourists over the past five years but she has spent a great deal of her time in social activities that rebounded to the benefit of the Museum.

She told her Trustees:

> Wherever I may be, I will always be concerned with the welfare of this museum. I feel proud of its expansion and accomplishments...I hope and believe that with renewed vitality it will uphold the standards and ideals with which it was established and continue its manifestation as an inspiring Art center of the West Coast.... Above all I believe in showing quality whether in extreme modern or academic art. A museum must stimulate the interest for art among the public through a diverse schedule of exhibitions based on a highly selective standard....

After her retirement in 1957, several years of world travels followed, taking her to the Middle and Far East, Australia, New Zealand, South, East, Central and North Africa, the West Indies and over most of Europe. In 1963, Mrs. Story was asked to become Staff Specialist in Art to the University of California's Art Galleries (now Museum) at Santa Barbara. She once more put her talents to work in selecting and organizing exhibitions, among which were:

A Retrospective Exhibition of Paintings by William Merritt Chase, 1964-65
Surrealism—A State of Mind, 1966
Five Centuries of Prints, 1967
Paul Klee, 1967
The First Retrospective Exhibition in the West of Max Weber, 1968
Trends in 20th Century Art, 1970
Constructivist Tendencies, 1970

Following this association, Mrs. Story donated to the University Art Museum over 50 master prints dating from the sixteenth through the eighteenth centuries. This gift formed the basis for a study collection which continues to be supplemented by gifts from other collectors. In 1968, the University of California conferred upon her the honorary degree of Master of Fine Arts in recognition of her active and respected role in the world of art in England and the United States.

Ala Story died on Easter Sunday, 1972.

THE ALA STORY COLLECTION OF INTERNATIONAL MODERN ART

Dimensions are given in centimeters, with inches in parentheses.
Height precedes width and depth.

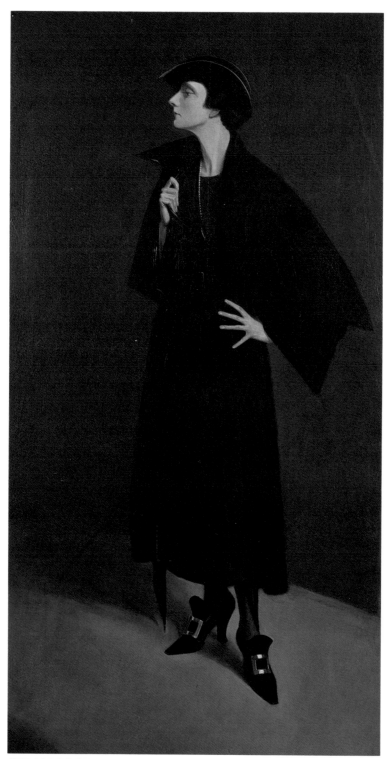

ABRAM POOLE, *Portrait of Mercedes de Acosta*, 1923

PAINTINGS

ALICE BABER
American (1928-1982)
Wheel of Day, 1971
Oil on canvas
149.2 x 201.9 (58¾ x 79½)
Gift of the artist
1971.21

HERBERT BAYER
Austrian, active America (b. 1900)
Ancient Secrets, 1978
Acrylic on paper
56.2 x 75.5 (22⅛ x 29¾)
Chalifoux/Story Purchase Funds
1979.13

HANS BURCKHARDT
Swiss, active America (b. 1904)
Approaching Storm, 1956
Oil on canvas
127 x 152.5 (50 x 60)
Ala Story Purchase Fund
1957.21

BRIAN CONNELLY
American (1926-1963)
Portrait of Ala Story, 1955
Casein on wood panel
42.5 x 30.5 (16¾ x 12)
Promised Gift

HANS ERNI
Swiss (b. 1909)
The Foal, 1950
Tempera on paper
98.2 x 149.7 (38⅝ x 58⅞)
Gift of Margaret Mallory
1963.43

HOWARD FENTON
American (b. 1910)
Arch and Sea, 1982
Acrylic on canvas with oil overglaze
76.2 x 101.9 (30 x 40⅛)
Gift of the artist
1983.49

MORRIS GRAVES
American (b. 1910)
Owl, 1955
Tempera on paper
34.3 x 45.7 (13½ x 18)
Promised Gift

ADRIAN HEATH
English (b. 1920)
Composition, 1959
Oil on canvas
40.7 x 35.5 (16 x 12)
Gift of Hanover Gallery, London
1964.37

ERNEST LUDWIG KIRCHNER
German (1880-1938)
Davos, ca. 1924
Oil on canvas
40.6 x 50.8 (16 x 20)
Promised Gift

PIERRE CÉSAR LAGAGE
French (b. 1911)
Abstract Composition, 1959
Oil on panel
64.3 x 48.7 (25¼ x 19⅛)
Ala Story Purchase Fund
1960.14

GRANDMA MOSES
(Anna Mary Robertson Moses)
American (1860-1961)
A Storm Is on the Water Now, 1947
Oil on board
40.6 x 50.8 (16 x 20)
Promised Gift

LEE MULLICAN
American (b. 1919)
Green Nature, 1967
Oil on canvas
88.9 x 190.5 (35 x 75)
Gift of Alice Erving to the Ala Story
 Collection
1972.18.1

LEE MULLICAN
American (b. 1919)
California Poster, 1969
Acrylic on canvas
128.2 x 102.2 (50½ x 40½)
Gift of the artist
1971.20

MARION PIKE
American (b. 1913)
Portrait of a Polish Woman, 1966
Oil on board
111.7 x 94 (44 x 37)
Gift of the artist
1971.26

ABRAM POOLE
American (1883-1961)
Portrait of Mercedes de Acosta, 1923
Oil on canvas
200.6 x 100.3 (79 x 39½)
Gift of Mercedes de Acosta
1960.26

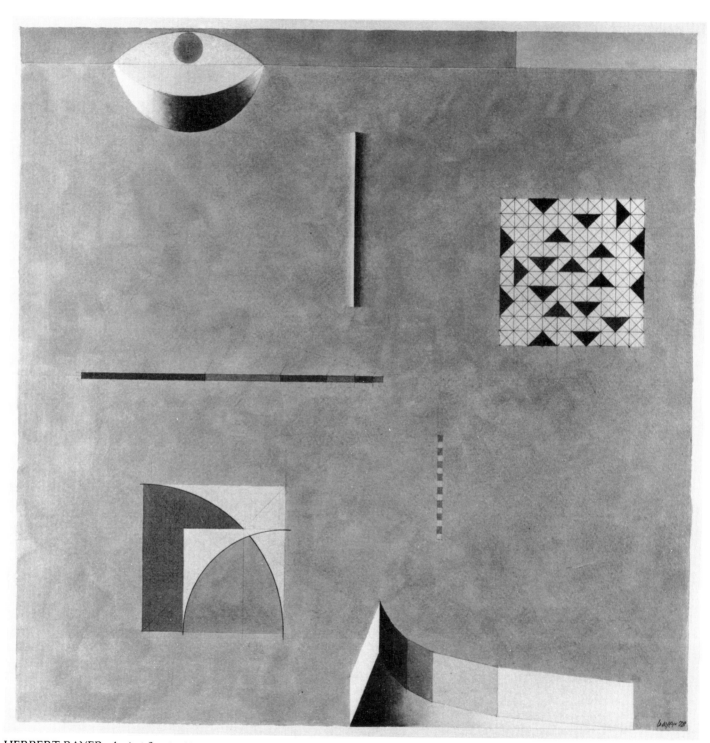

HERBERT BAYER, *Ancient Secrets*, 1978

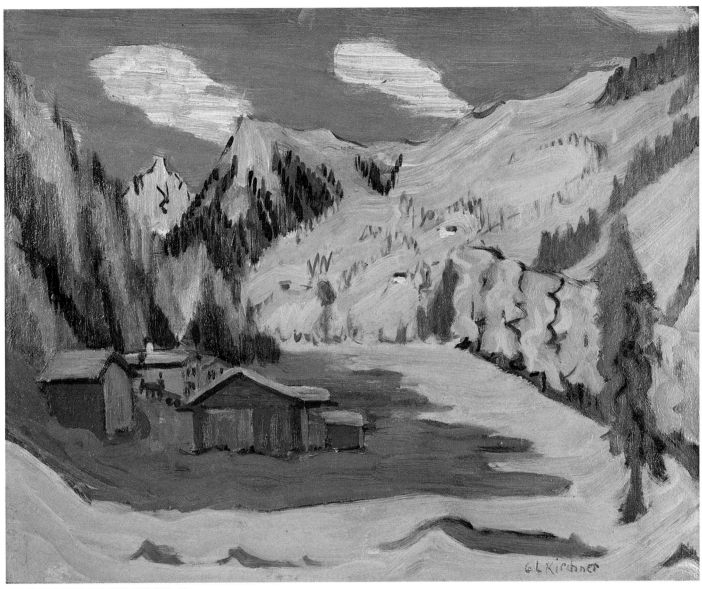

ERNEST LUDWIG KIRCHNER, *Davos*, ca. 1924

ERNEST POSEY
American (b. 1937)
Quatrafoil, 1970
Acrylic on canvas
114.9 x 114.9 (45¼ x 45¼)
Gift of Margaret Mallory and
 Wright S. Ludington
1970.35

RAIMONDS STAPRANS
American (b. 1926)
Row of Boats, 1963
Oil on canvas
69.8 x 85.1 (27½ x 33½)
Gift of Maxwell Galleries
1963.35

WALTER STUEMPFIG
American (1914-1970)
Lower Philadelphia
Oil on canvas
25.7 x 36.2 (10⅛ x 14¼)
Gift of Margaret Mallory
1968.44.1

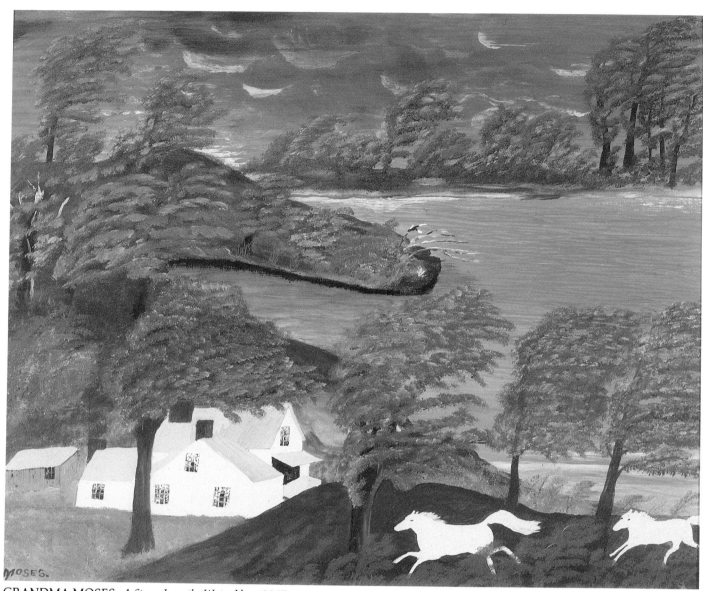

GRANDMA MOSES, *A Storm Is on the Water Now*, 1947

LEE MULLICAN, *California Poster*, 1969

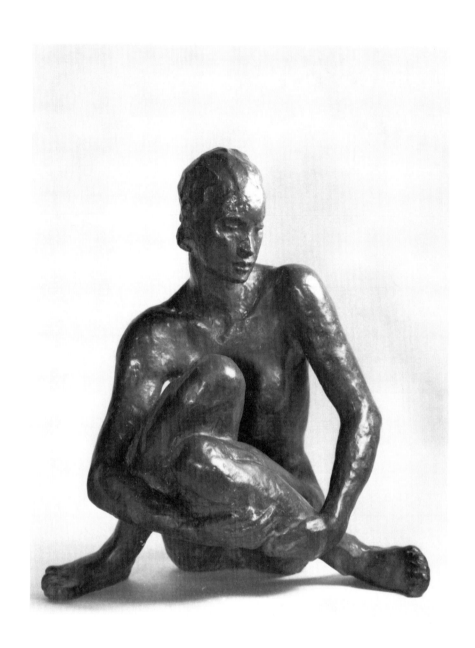

GEORG KOLBE, *Die Sitzende*, 1926

SCULPTURE

RICHMOND BARTHÉ
American (b. 1901)
Julius, ca. 1940
Plaster of Paris (painted with dark
 wash)
16.5 x 10.1 x 12.7 (6½ x 4 x 5)
Gift of Ala Story
00.184

ROBERT CREMEAN
American (b. 1932)
Fragment for a Deposition No. 1, 1960
Wood mortise
195.7 height (77)
Promised Gift of Robert and Esther
 Robles
1984.27

GUITOU KNOOP
Dutch, active France (b. 1909)
Abstraction No. 1
Lead
22.2 x 27.9 x 13.1 (8¾ x 11 x 5⅛)
Promised Gift

GEORG KOLBE
German (1877-1947)
Die Sitzende, 1926
 (Seated Girl)
Bronze
28.6 x 22.8 x 18.7 (11¼ x 9 x 7⅜)
Promised Gift

KARL HEINZ KRAUSE
German (b. 1924)
'64 Olympionike, 1960
Bronze
45.7 x 50.1 x 33.0 (18 x 19¾ x 13)
Promised Gift

RENEÉ SINTENIS
German (1888-1965)
Self-Portrait
Cast stone
33.6 x 15.2 x 21.6 (13¼ x 6 x 8½)
Promised Gift

ANN MALLORY
American (b. 1949)
Pot
Ceramic
25.4 x 30.5 (10 x 12)
Promised Gift

BEATRICE WOOD
American (b. 1893)
Gold Luster Vase, 1965
Glazed pottery
25.7 x 22.6 (10⅛ x 8⅞)
Gift of the artist
1967.11

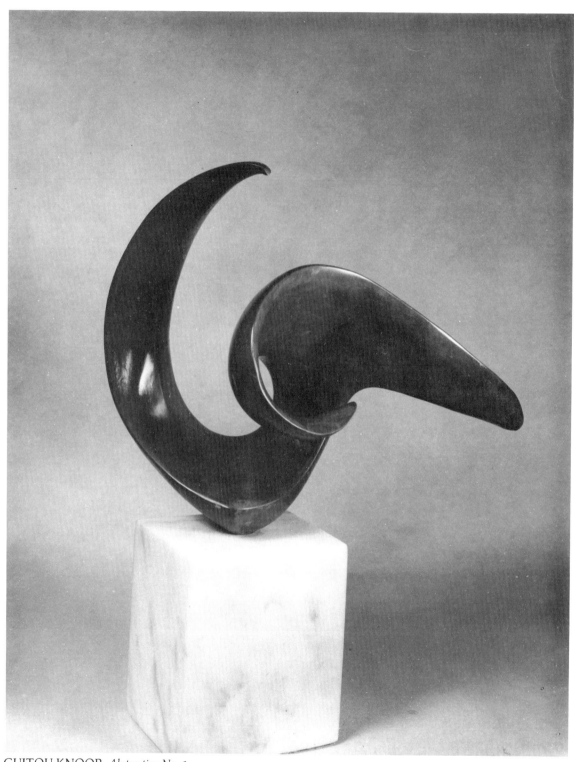

GUITOU KNOOP, *Abstraction No. 1*

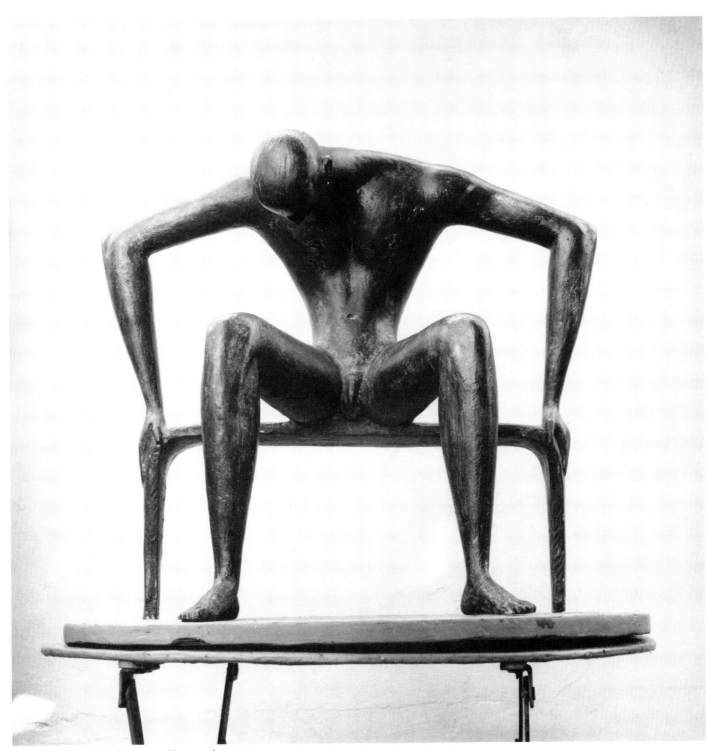

KARL HEINZ KRAUSE, '64 Olympionike, 1960

RENEÉ SINTENIS, *Self-Portrait*

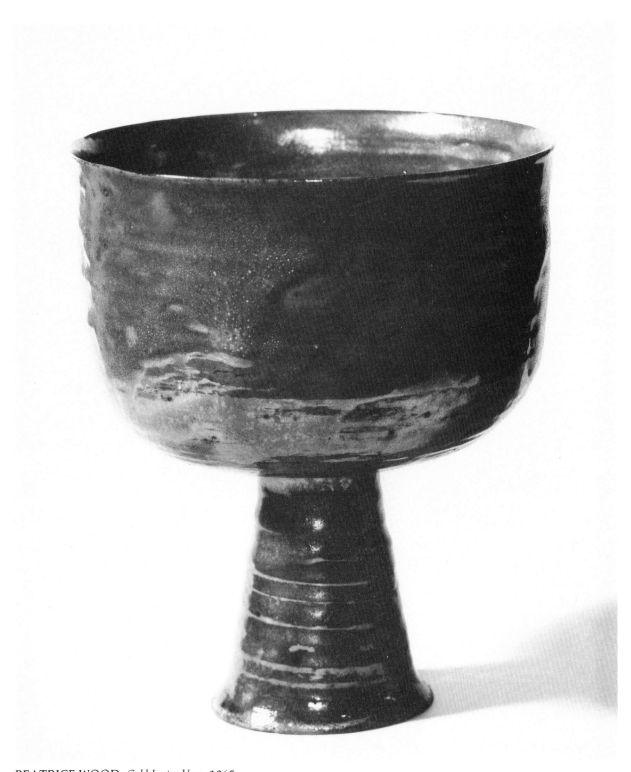

BEATRICE WOOD, *Gold Luster Vase*, 1965

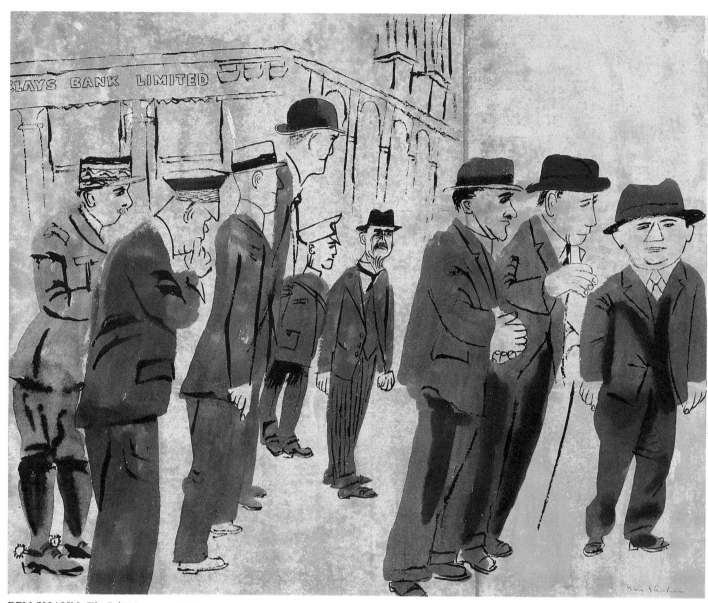

BEN SHAHN, *The Politicians*, ca. 1939

WATERCOLORS, PASTELS & DRAWINGS

MILTON AVERY
American (1893-1965)
Female Nude, 1956
Lithocrayon
43.2 x 35.6 (17 x 14)
Promised Gift

TREVOR BELL
English (b. 1930)
Large Blocks, 1960
Gouache
56.4 x 46.6 (22⅛ x 18¼)
Gift of Mr. and Mrs. Howard
　Fenton
1973.9.1

EUGENE BERMAN
Russian, active America
　(1899-1972)
Figure in Doorway, 1931
Ink
32.4 x 38.1 (12¾ x 15)
Promised Gift

DONALD BORTHWICK
American (b. 1933)
Reclining Nude on Sofa, 1968
Mixed media
51.4 x 74.6 (20¼ x 29⅜)
Gift of Mr. and Mrs. Joseph Halle
　Schaffner
1971.15.1

MORRIS BRODERSON
American (b. 1928)
Mother and Child, 1961
Watercolor
64.1 x 84.5 (25¼ x 33¼)
Gift of Margaret Mallory
1966.39

DOROTHY W. BROWN
American (1899-1973)
Sunday on the Beach
Watercolor
36.8 x 44.4 (14½ x 17½)
Gift of the artist
1968.43

HANS BURCKHARDT
Swiss, active America (b. 1904)
Three Women, 1949
Pastel
42.5 x 50.2 (16¾ x 19¾)
Gift of the Artist
1966.56

BERNARD BUFFET
French (b. 1928)
Street Scene, 1953
Oil and pencil
50 x 63.8 (19⅝ x 25⅛)
Gift of Mr. and Mrs. Hugh
　Chisholm, Jr.
1965.64

WILLIAM DOLE
American (1917-1983)
Ala's Story, 1971
Collage design for the cover of the
　Ala Story Catalogue
34.3 x 30.5 (13½ x 12)
Promised Gift

WILLIAM DOLE
American (1917-1983)
Florence, 1957
Ink
31 x 20.9 (12⅛ x 8¼)
Gift of Margaret Mallory
1960.31

RAOUL DUFY
French (1877-1953)
Marseille, 1903
Watercolor
59.7 x 66 (23½ x 26)
Gift of Mr. and Mrs. Joseph Halle
　Schaffner
1971.15.5

LYONEL FEININGER
German, active America (1871-1956)
Steamships, 1944
Watercolor
31.1 x 47.6 (12¼ x 18¾)
Promised Gift

LÉONOR FINI
Argentine, active France (b. 1908)
Two Dancers
Ink on blue paper
30.7 x 24.1 (12⅛ x 9½)
Promised Gift

MARTIN FROY
English (b. 1926)
Figure
Pencil and colored pencil
38.4 x 28.2 (15⅛ x 11⅛)
Gift of English Friends in memory
　of Ala Story
1973.6.3

HENRI GAUDIER-BRZESKA
French (1891-1915)
Seated Female Nude, 1912-1913
Charcoal
24.8 x 37.4 (9¾ x 14¾)
Promised Gift

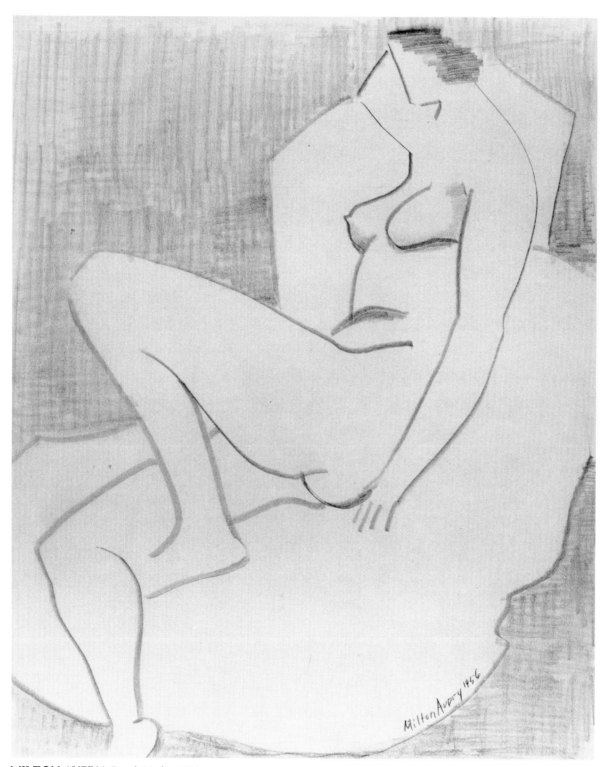

MILTON AVERY, *Female Nude*, 1956

GEORGE GROSZ
German (1893-1959)
Young Ladies (recto) 1919-1920
Four Men (verso), 1919-1920
Pen and ink
62.8 x 50.8 (24¾ x 20)
63.5 x 51.4 (25 x 20¼)
Gift of Frank Perls
1966.3 a,b

VERONICA HELFENSTELLER
American (1910-1964)
Aviary Doorway
Pencil, ink and gold wash
34.6 x 26.7 (13⅝ x 10½)
Gift of Ala Story
1953.6

JOHN HULTBERG
American (b. 1922)
Sketch for Train, 1960
Gouache
54 x 73.7 (21¼ x 29)
Gift of Alice Erving
1972.18.2

OLGA IVANJIKI
Russian, active Yugoslavia (b. 1931)
Windy Day, 1966
 (Cosmonaut Alexei Leonow—
 First Man to Walk in Space)
Ink and watercolor
59.4 x 43.2 (23⅜ x 17)
Gift of the artist
1966.59

PAUL KLEE
Swiss (1879-1940)
NR. 187, 1919
Ink
20.6 x 21.6 (8⅛ x 8½)
Gift of Margaret McLennan Morse
1967.32

FRANTISEK KUPKA
Czechoslovakian, active France
 (1871-1957)
Étude pour "Traits Profonds," 1923
 (Study for Penetrating Planes)
Gouache
33.6 x 37.1 (13¼ x 14⅝)
Gift of Fred Maxwell
1965.56

RICO LEBRUN
American (1900-1964)
Pomona Mural (Fourth Sketch), 1960
Ink
34.2 x 24.3 (13½ x 9½)
Gift of Miss Dorothy Brown
1968.36.2

JOHN LINCOLN
American (b. 1932)
Carnations, 1961
Ink and wash
53.3 x 66 (21 x 26)
Gift of Margaret Mallory
1966.61

WALTER LINDAUER
American (b. 1917)
Ghostley Towers of Yea, Nay and Maybe,
 1967
Ink drawing
65.7 x 40.3 (25⅞ x 15⅞)
Gift of Margaret Mallory
1968.34.2

HENRY MOORE
English (b. 1898)
Studies for Sculpture, 1950
Watercolor
32.4 x 38.1 (12¾ x 15)
Promised Gift

LEE MULLICAN
American (b. 1919)
Untitled, 1950
Crayon
35.2 x 42.9 (13⅞ x 16⅞)
Gift of Walter G. Silva
1971.71.1

EMIL NOLDE
German (1867-1956)
The Lovers (Self-Portrait with
 his Wife, Ada), 1932
Watercolor
33.6 x 49.5 (13¼ x 19½)
Promised Gift

NATHAN OLIVEIRA
American (b. 1928)
Two Nudes, 1967
Sepia, black ink and wash
47.9 x 40 (18⅞ x 15¾)
Gift of William Brown
1971.11

JULES PASCIN
French, active America (1885-1930)
Femmes au Table
 (Women at the Table)
Pen and ink on tracing paper
18.9 x 28.5 (7⅜ x 11⅛)
Gift of Mr. and Mrs. Joseph Halle
 Schaffner
1971.15.4

MAX PECHSTEIN
German (1881-1955)
Mother with Child on a Hobby-Horse,
 1916
Conte crayon with black ink on
 utility paper
54.9 x 43.2 (21⅝ x 17)
Gift of Mr. and Mrs. Joseph Halle
 Schaffner
1971.15.3

PABLO PICASSO
Spanish (1881-1973)
Self-Portrait, 1906
Pen and ink
30.8 x 22.8 (12⅛ x 9)
Promised Gift

MARIE-ANNE PONIATOWSKA
French, active America (b. 1931)
Self-Portrait #2, 1962
Pencil
40.9 x 40.9 (16⅛ x 16⅛)
Gift of Katherine Harvey
1962.11

WADE REYNOLDS
American (b. 1929)
Portrait of Dame Judith Anderson, 1973
Pencil and chalk
54.6 x 80 (21½ x 31½)
Gift of Jack Gage
1973.16

DIEGO RIVERA
Mexican (1886-1957)
Tehuantepec Woman
Watercolor
43.4 x 32.4 (17⅛ x 12¾)
Gift of Dr. and Mrs. MacKinley
 Helm
1957.7

BEN SAKOGUCHI
American (b. 1938)
Fat Satrap with Friends
Pencil
44.4 x 65.1 (17½ x 25⅝)
Gift of Miss Dorothy Brown
1965.21

EGON SCHIELE
Austrian (1890-1918)
Two Figures, 1916
Pencil
40.9 x 51.7 (16⅛ x 20⅜)
Anonymous Gift
1966.55

BEN SHAHN
American (1898-1969)
The Politicians, ca. 1939
Watercolor
27.9 x 35.6 (11 x 14)
Promised Gift

GILBERT SPENCER
English (b. 1892)
Grasmere Under Snow, 1941
Watercolor and pencil
60 x 48.9 (23⅝ x 19¼)
Gift of Ala Story
1966.63

SAUL STEINBERG
Romanian, active America (b. 1914)
Piazza San Marco, 1951
Pen and ink, crayon and watercolor
55.5 x 75.9 (21⅞ x 29⅞)
Gift of Mrs. Joseph Halle Schaffner
1974.34

JAN STUSSY
American (b. 1921)
Woman Reading
Mixed Media
62.8 x 47.8 (24¾ x 18¾)
Gift of Miss Dorothy Brown
1968.36.1

ERNST VAN LEYDEN
Dutch, active Paris and Venice
 (b. 1892)
Jaune Vert, 1960
 (Yellow Green)
Collage
40 x 47.2 (15½ x 18¼)
Ala Story Purchase Fund
1962.18

HOWARD WARSHAW
American (1920-1977)
Cattle, 1958
Ink wash
46.7 x 61.6 (18⅜ x 24¼)
Gift of Margaret Mallory
1966.60

MAX WEBER
Russian, active America
 (1881-1961)
Nude, 1943
Blue ink
14 x 12.1 (5½ x 4¾)
Gift of Ala Story
1968.35.2

JOHN WILDE
American (b. 1919)
The Common Thrasher, Twice, 1955
Ink, pencil and watercolor
61.3 x 52.7 (24⅛ x 20¾)
Promised Gift

JACK ZAJAC
American (b. 1929)
Birds in Flight, 1953
Wash drawing
64.7 x 49.5 (25½ x 19½)
Promised Gift

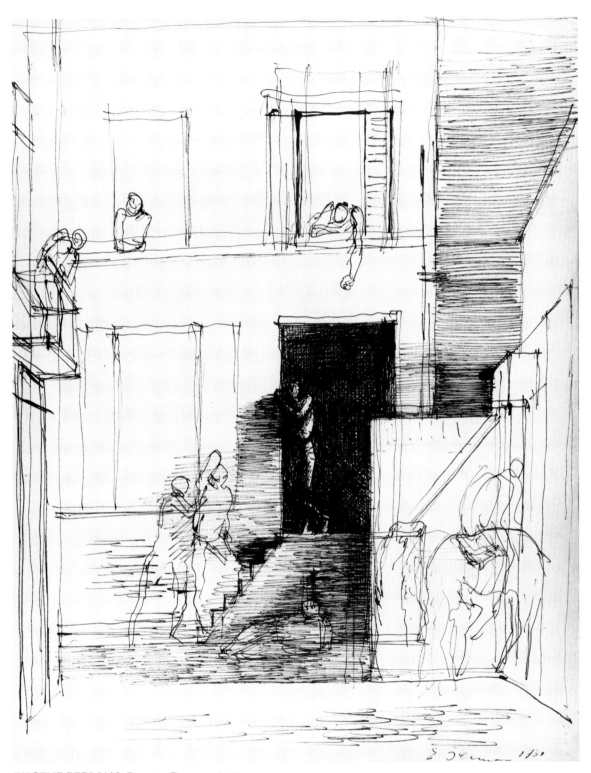

EUGENE BERMAN, *Figure in Doorway,* 1931

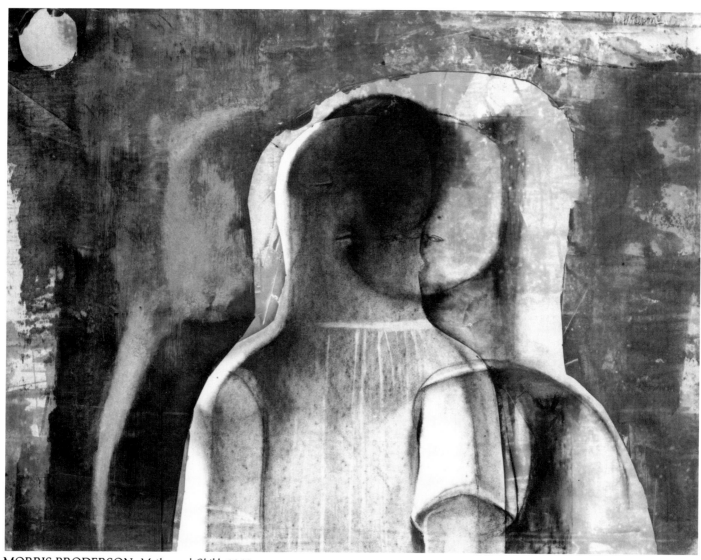

MORRIS BRODERSON, *Mother and Child*, 1961

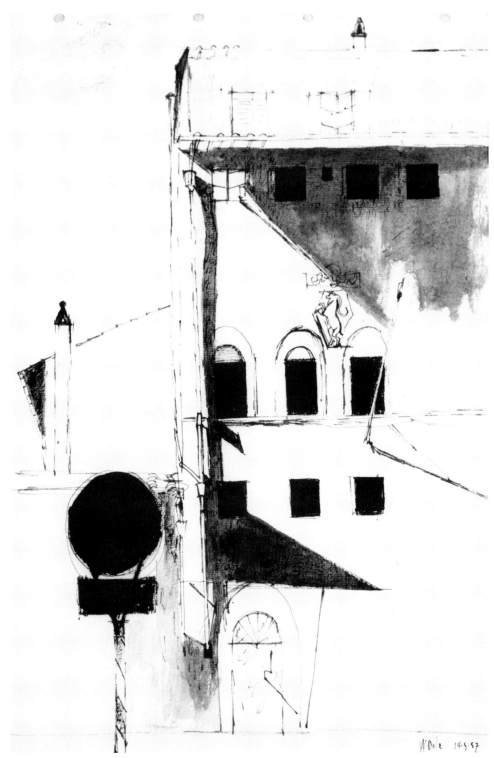

WILLIAM DOLE, *Florence, 1957*

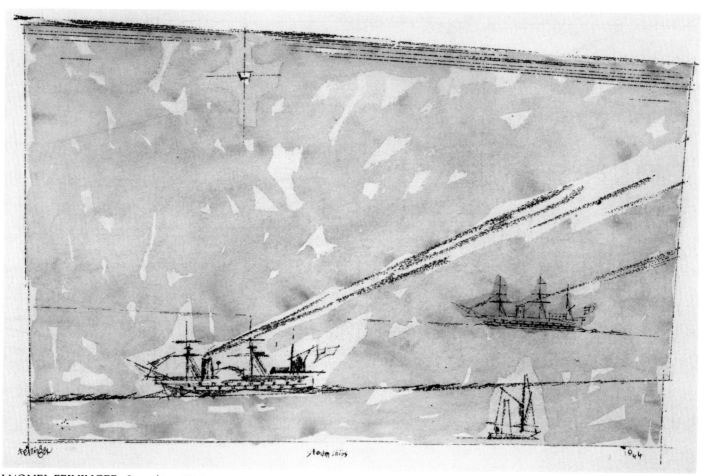

LYONEL FEININGER, *Steamships*, 1944

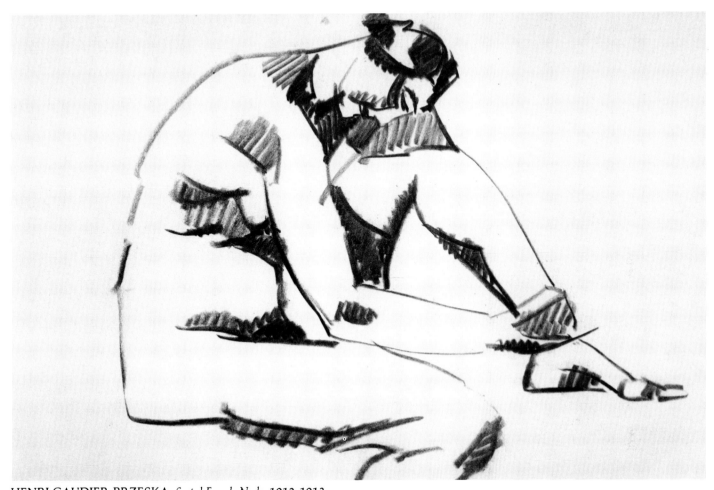

HENRI GAUDIER-BRZESKA, *Seated Female Nude*, 1912-1913

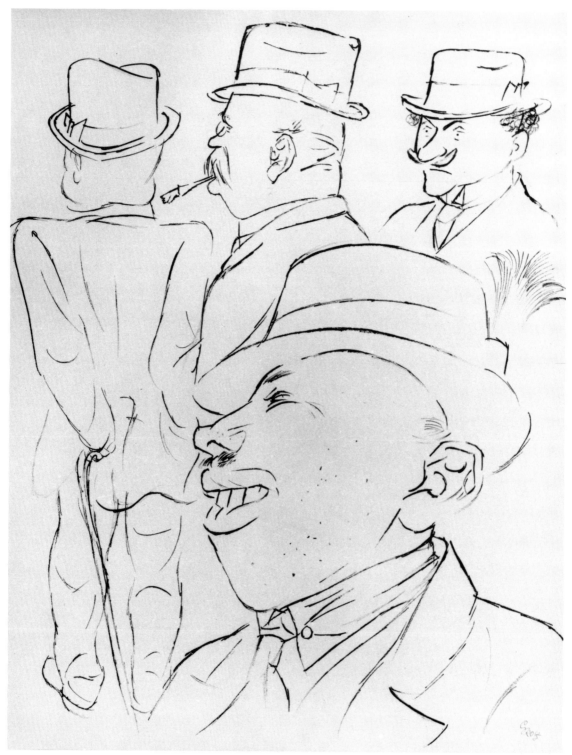

GEORGE GROSZ, *Four Men (verso)*, 1919-1920

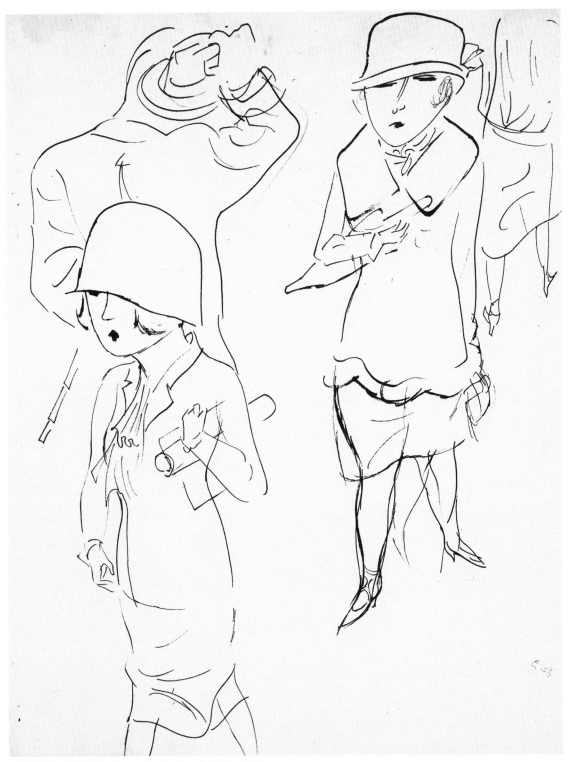

GEORGE GROSZ, *Young Ladies (recto),* 1919-1920

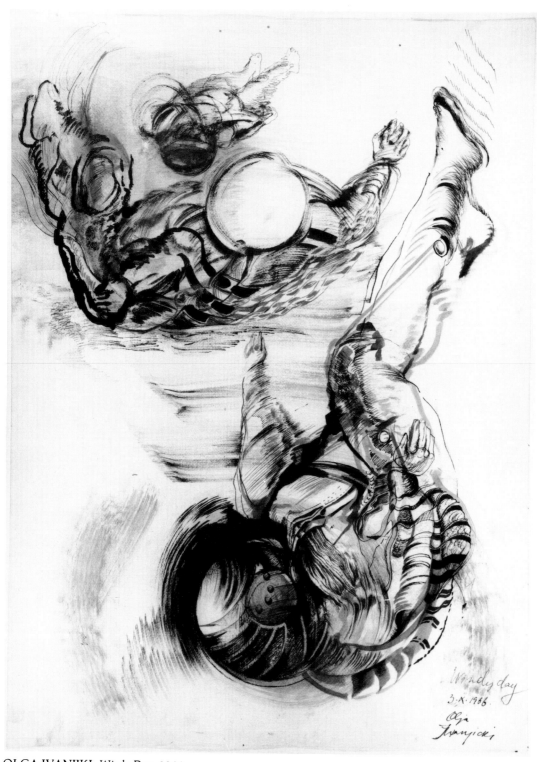

OLGA IVANJIKI, *Windy Day*, 1966

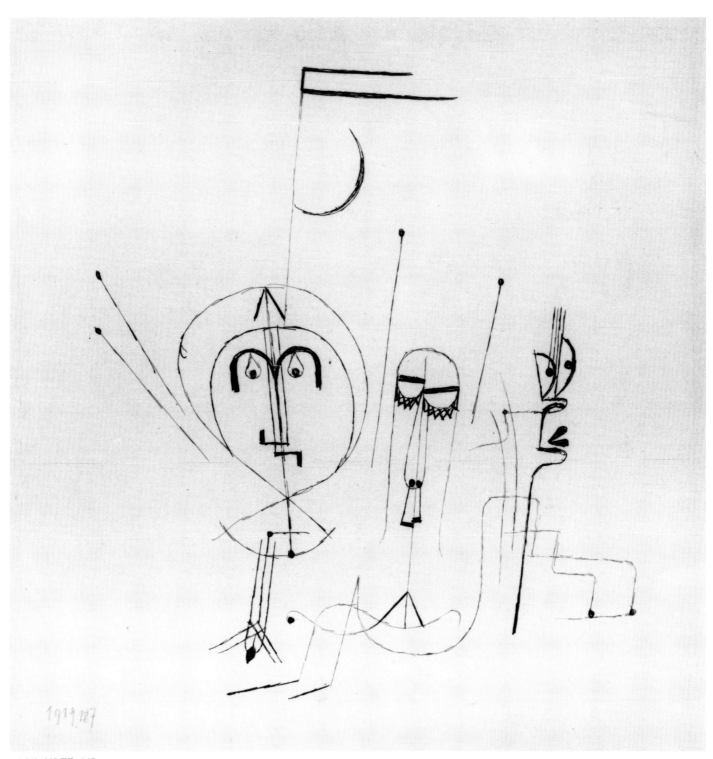

PAUL KLEE, *NR. 187*, 1919

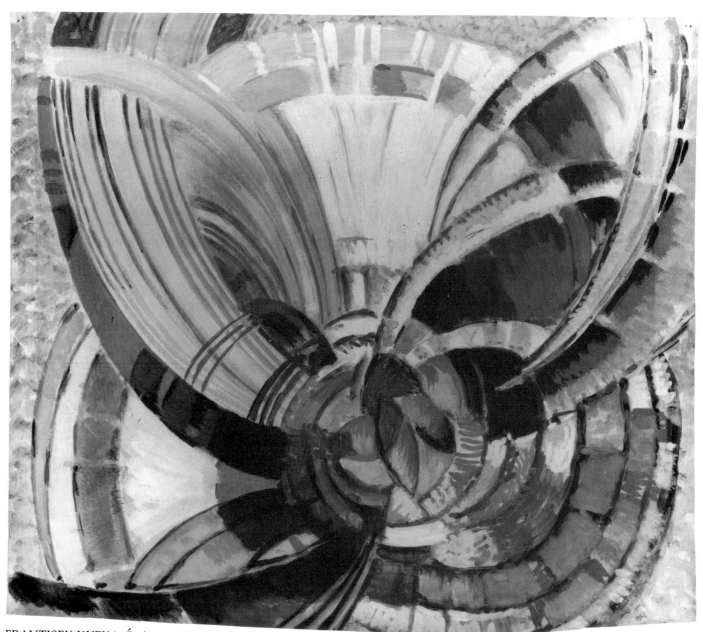

FRANTISEK KUPKA, *Étude pour "Traits Profonds,"* 1923

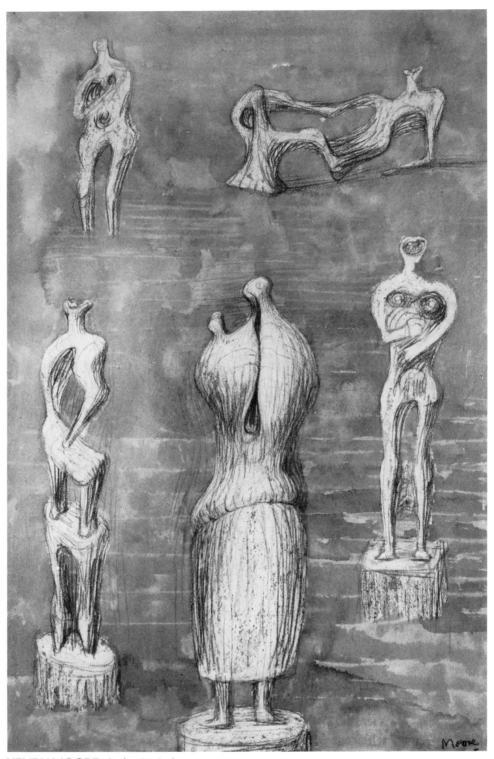

HENRY MOORE, *Studies for Sculpture*, 1950

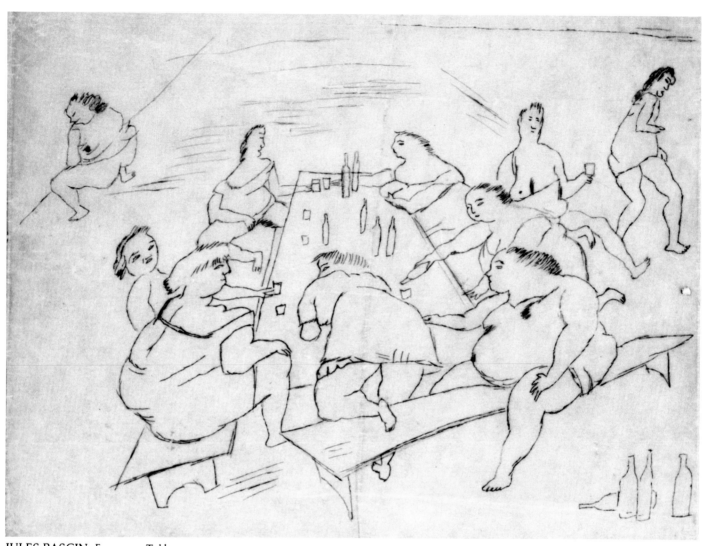

JULES PASCIN, *Femmes au Table*

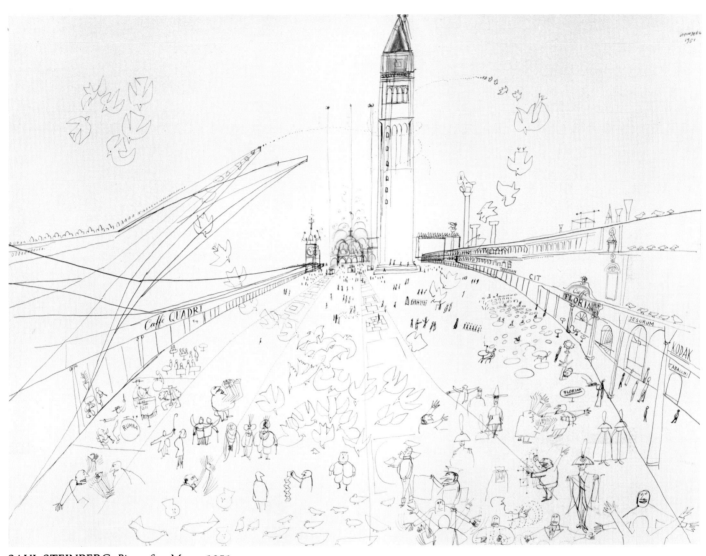

SAUL STEINBERG, *Piazza San Marco*, 1951

MARIE-ANNE PONIATOWSKA, *Self-Portrait #2, 1962*

WADE REYNOLDS, *Portrait of Dame Judith Anderson, 1973*

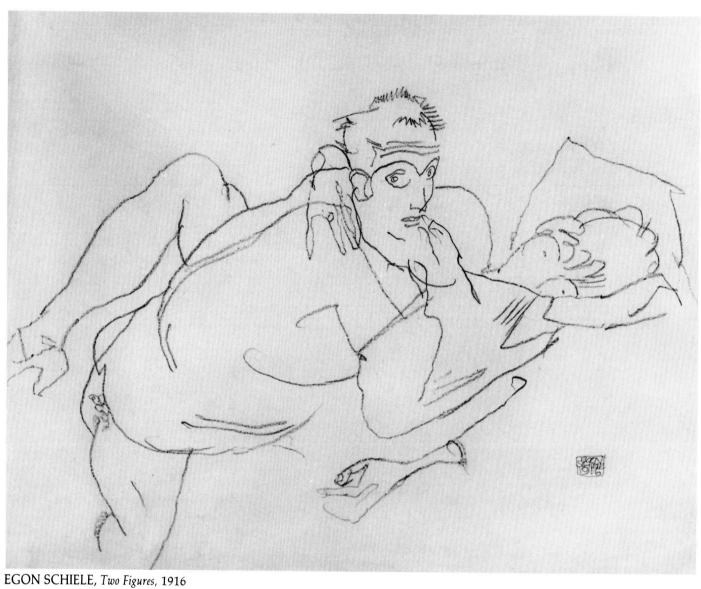

EGON SCHIELE, *Two Figures,* 1916

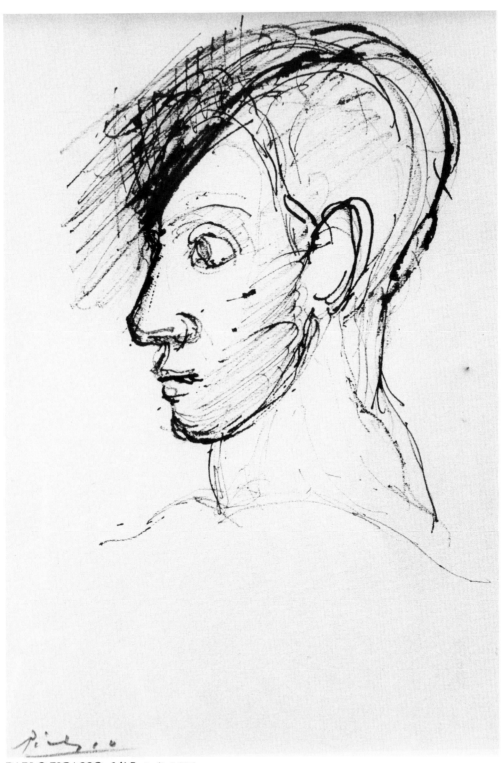

PABLO PICASSO, *Self-Portrait*, 1906

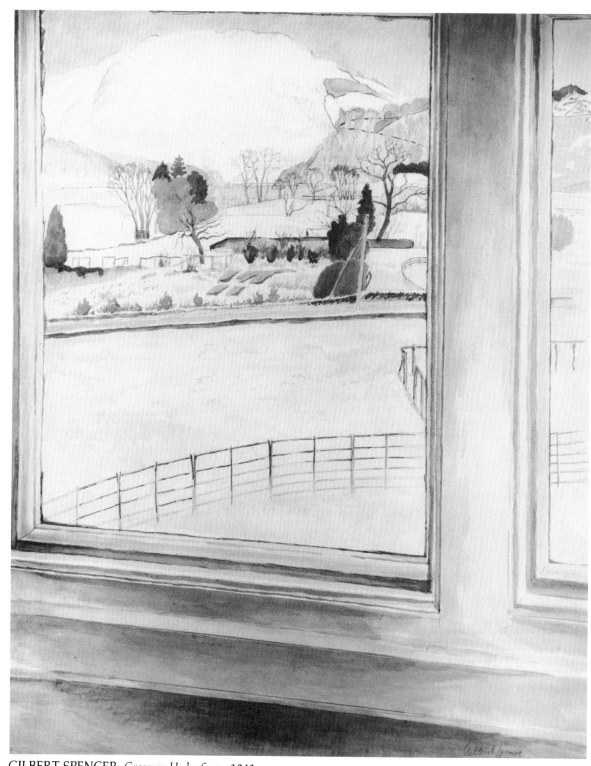

GILBERT SPENCER, *Grasmere Under Snow*, 1941

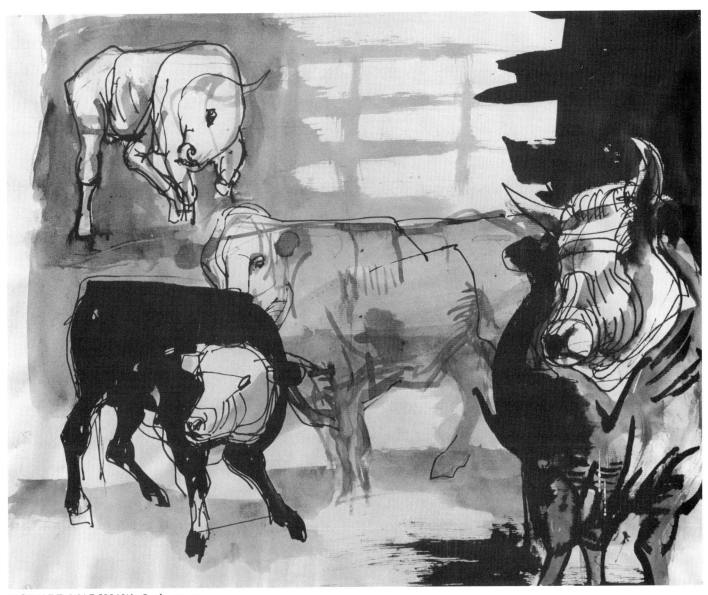

HOWARD WARSHAW, *Cattle, 1958*

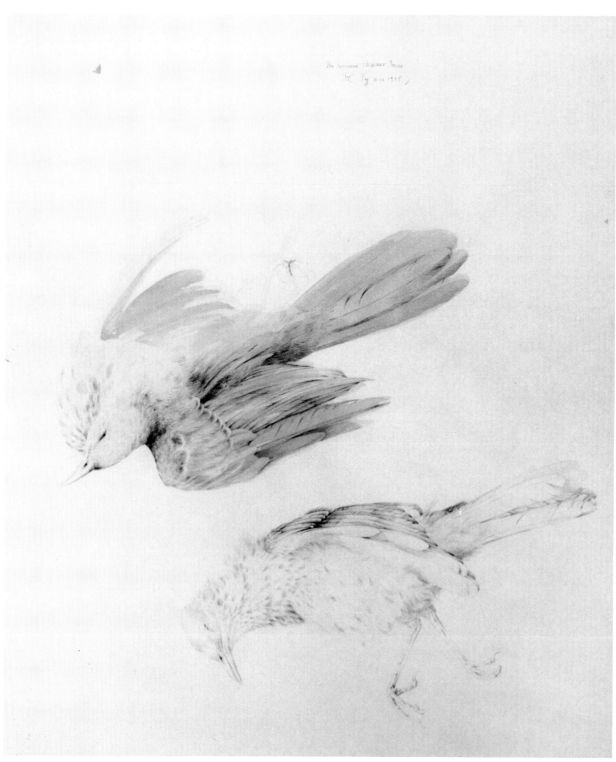

JOHN WILDE, *The Common Thrasher, Twice*, 1955

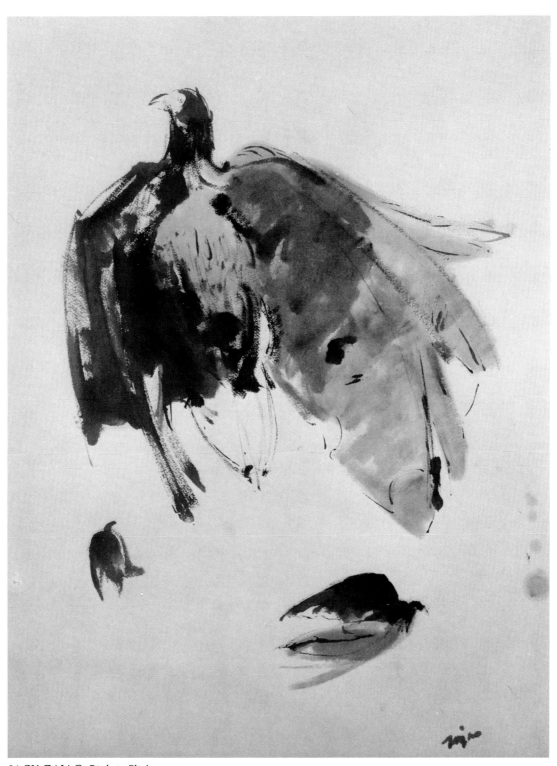

JACK ZAJAC, *Birds in Flight,* 1953

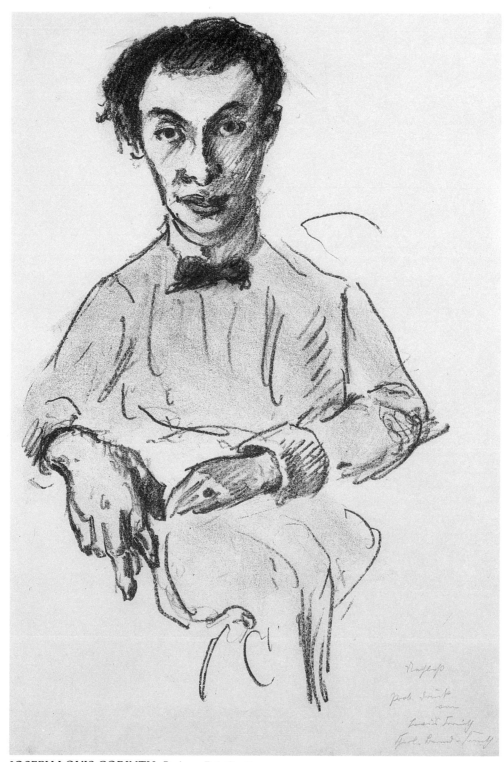

JOSEPH LOVIS CORINTH, *Professor Eric Goeritz*

PRINTS

HANS ARP
German, active France (1887-1966)
Avant Être Musique, 1950
Woodcut
66 x 49.5 (26 x 19½)
Gift of Beatrice Farwell
1972.13

ERNST BARLACH
German (1870-1938)
Lame, Blind and Old Beggars, 1919
Woodcut
19.3 x 14.6 (7⅝ x 5¾)
Gift of Erica Anderson
1966.62

ERNST BARLACH
German (1870-1938)
Schlechtes Gewissen, 1917
 (Guilty Conscience)
Lithograph
31.7 x 39.3 (12½ x 15½)
Gift of Margaret Mallory
1976.27

LEONARD BASKIN
American (b. 1922)
Portrait of Chaim Soutine
Engraving
22.8 x 18.4 (9 x 7½)
Gift of Dr. and Mrs. Eugene
 Anderson
1972.15.1

TREVOR BATES
English (b. 1921)
Untitled
Lithograph (1/50)
44.1 x 33 (17⅜ x 13)
Gift of Margaret Mallory
1973.6.8

HERBERT BAYER
Austrian, active America (b. 1900)
Seven Convolutions, 1948
Color lithograph
45.7 x 55.9 (18 x 22)
Gift of Mrs. John W. Stewart
1971.68.1-7

MAX BECKMANN
German, active America (1884-1950)
The Snake Charmer, 1921
Drypoint on buttered paper
29 x 25.3 (11⅜ x 10⅞)
Ala Story Purchase Fund
1965.26

FRANK BRANGWYN
English (1867-1956)
The Moat
Etching
29.8 x 40.3 (11¾ x 15⅞)
Gift of Ala Story
1968.35.3

ALEXANDER CALDER
American (1898-1976)
Untitled
Color lithograph (59/130)
72.7 x 53.6 (28⅝ x 21⅛)
Gift of Margaret Mallory
1968.44.2

ROBERT ALLAN CALE
American (b. 1940)
Passing Thoughts, 1970
Color lithograph
64.7 x 49.6 (25½ x 19½)
Gift of Margaret Mallory
1978.34

HEINRICH CAMPENDONK
Dutch, active Germany (1889-1957)
Composition with Animals, 1916
Woodcut
24.9 x 32.1 (9¾ x 12⅝)
Ala Story Purchase Fund
1965.31

CHRISTOPHER CORDES
American (b. 1945)
Weather Series #1 or *P-Super: English
 Image*, 1969
Color lithograph (5/5)
59.7 x 41.9 (23½ x 16½)
Gift of Margaret Mallory
1970.36.2

JOSEPH LOVIS CORINTH
German (1858-1925)
Professor Eric Goeritz
Color lithograph
51.4 x 35.6 (20¼ x 14)
Gift of Margaret Mallory
1965.24

JOSEPH LOVIS CORINTH
German (1858-1925)
Potiphar's Wife
Etching
31.1 x 35.6 (12¼ x 14)
Anonymous Gift
1976.37.1

JOSEPH LOVIS CORINTH
German (1858-1925)
Portrait of Marczinsky, 1923
Lithograph
71.7 x 57.3 (28¼ x 22½)
Anonymous Gift
1976.37.2

JOSEPH LOVIS CORINTH
German (1858-1925)
Portrait of Marczinsky, 1923
Lithograph
71.1 x 52.7 (28 x 20¾)
Anonymous Gift
1976.37.3

JOSEPH LOVIS CORINTH
German (1858-1925)
Frau im Bett, 1918
Lithograph
46.3 x 59.7 (18¼ x 23½)
Anonymous Gift
1976.37.4

JOSEPH LOVIS CORINTH
German (1858-1925)
Homerian Laughter, 1920
Drypoint and etching, 4th State
 (5/50)
34.3 x 51.6 (13½ x 20¼)
Anonymous Gift
1979.53

SALVADOR DALI
Spanish (b. 1904)
Washington Square, 1969
Lithograph (21/125)
42.5 x 62.2 (16¾ x 24½)
Anonymous Gift
1971.12

DON EDDY
American, (b. 1944)
DC 8, 1970
Serigraph
55.8 x 76.2 (22 x 30)
Gift of Ala Story
1970.37.2

LYONEL FEININGER
German, active America
 (1871-1956)
The Lantern, 1918
Woodcut
16.8 x 25.2 (6⅝ x 9⅞)
Gift of Mrs. Donald Bear
1966.2

SAM FRANCIS
American (b. 1923)
Upper Yellow (Yellow over Blue 13), 1960
Lithograph
61.2 x 86.6 (24⅛ x 34⅛)
Gift of Ala Story
1963.4

ADOLPH GOTTLIEB
American (1930-1974)
Arabesque, 1967
Color serigraph
54.9 x 75.3 (21⅝ x 29⅝)
Gift of Margaret Mallory and
 F. Bailey Vanderhoef, Jr.
1968.19

MARSDEN HARTLEY
American (1877-1943)
Pears in a Basket, 1923
Lithograph
40.6 x 53.6 (16 x 21⅛)
Ala Story Purchase Fund
1965.30

STANLEY WILLIAM HAYTER
English (b. 1901)
Combat, 1936
Intaglio (engraving and soft-ground
 etching): Trial proof
40 x 48.9 (15¾ x 19¼)
Promised Gift

ERICH HECKEL
German (1883-1970)
Young Clown, 1930
Colored woodblock print
29.2 x 15.2 (11½ x 6)
Promised Gift

FLORENCE HENRI
American (b. 1893)
Untitled, 1923
Serigraph
49.8 x 34.9 (19⅝ x 13¾)
Gift of Margaret Mallory
1973.6.4

MASUO IKEDA
Japanese, active America (b. 1934)
Sky Wall, 1968
Color lithograph
63.8 x 51.4 (25⅛ x 20¼)
Gift of Margaret Mallory
1970.36.1

YNEZ JOHNSTON
American (b. 1920)
Tamarind Color
Lithograph
76.2 x 57.1 (30 x 22½)
Gift of Walter G. Silva
1971.71.2

WASSILY KANDINSKY
Russian (1866-1944)
Kleine-Welten IX, 1922
Drypoint
23.8 x 19.7 (9⅜ x 7¾)
Gift of Robert M. Light
1971.10

MICHAEL KENNY
English (b. 1941)
Blantyre, 1969
Lithograph
69.2 x 102.5 (27¼ x 40⅜)
Gift of Margaret Mallory
1973.6.7

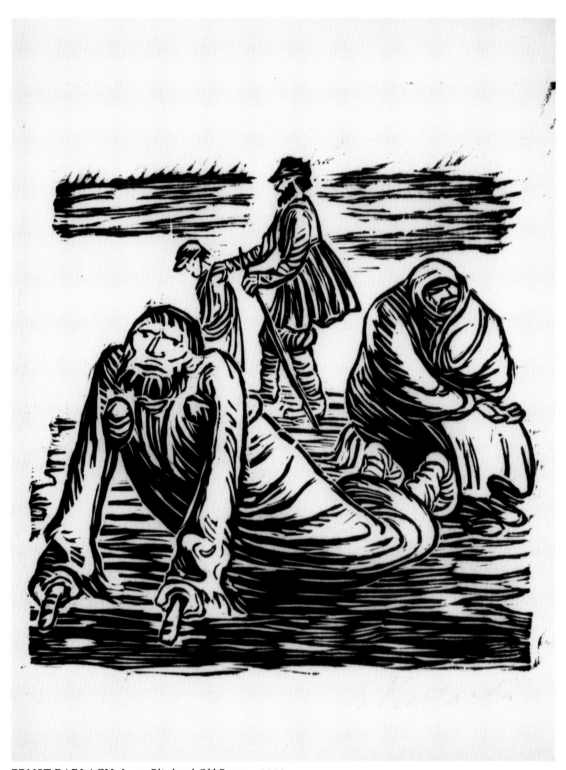

ERNST BARLACH, *Lame, Blind and Old Beggars,* 1919

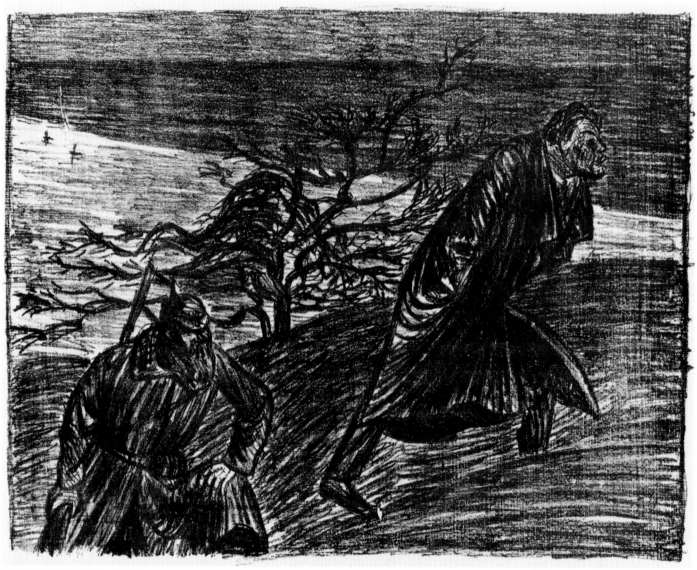

ERNST BARLACH, *Schlechtes Gewissen*, 1917

ROCKWELL KENT
American (1882-1971)
Masthead, 1926
Wood engraving on maple
20.3 x 14.0 (8 x 5½)
Gift of Jacob Zeitlin
1971.25

ERNEST LUDWIG KIRCHNER
German (1880-1938)
Head of the Dancer Nina Hardt, ca. 1922
Drypoint
31.4 x 24.9 (12⅜ x 9¾)
Ala Story Purchase Fund
1966.64

KEITH KIRTS
American (b. 1942)
Two Heads with Green Cat, 1969
Lithograph
45.7 x 38.1 (18 x 15)
Gift of Ala Story
1971.36

PAUL KLEE
Swiss (1879-1940)
Seiltanzer, 1923
 (Tight Rope Walker)
Color lithograph
43.2 x 26.7 (17 x 10½)
Gift of Mason B. Wells
1976.43

OSKAR KOKOSCHKA
Austrian (1886-1980)
Portrait of Max Reinhardt
Lithograph
74.9 x 56.2 (29½ x 22⅛)
Gift of Wright S. Ludington
1958.26

OSKAR KOKOSCHKA
Austrian (1886-1980)
Rachel
Lithograph
95.9 x 63.5 (37¾ x 25)
Anonymous Gift
1976.37.5

KÄTHE KOLLWITZ
German (1867-1945)
Seated Woman with Upraised Hand,
 1924
Lithograph
54.3 x 44.4 (21⅜ x 17½)
Gift of Margaret Mallory
1966.4

MAXIMILIAN KURZWEIL
Austrian (1867-1916)
Der Polster, 1903
Color woodcut on Japan paper
28.1 x 25.7 (11 x 10⅛)
Gift of Robert M. Light
1968.10

WILHELM VON LEHMBRUCK
German (1880-1919)
Large Head, 1912
Drypoint
29.5 x 25.9 (11⅝ x 10⅛)
Ala Story Purchase Fund
1966.65

ALBERTO LONGONI
Italian (b. 1921)
Rush Hour, 1967
Lithograph
58.3 x 39.7 (22⅞ x 15⅝)
Anonymous Gift
1971.2.1

GERHARD MARCKS
German (1889-1981)
Untitled (The Lovers)
Woodcut
29.2 x 21.6 (11½ x 8½)
Gift of Dr. and Mrs. Eugene
 Anderson
1972.15.2

FRANCIS W. MARTIN
American (b. 1904)
Women in Stockings, Blue and Red
Colagraph (silkscreen)
75.6 x 106.7 (29¾ x 42)
Gift of Margaret Mallory
1971.70

ROBERTO SEBASTIAN MATTA
Chilean (b. 1912)
Untitled, 1960
Color etching (40/50)
37.4 x 49.2 (14¾ x 19⅜)
Anonymous Gift
1966.5

RODRIGO MOYNIHAN
English (b. 1910)
Untitled
Lithograph
22.8 x 22.8 (9 x 9)
Gift of Margaret Mallory
1973.6.2

EDVARD MUNCH
Norwegian (1863-1944)
Violin Concert, 1903
Lithograph
52.1 x 67.3 (20½ x 26½)
Gift of Wright S. Ludington
1958.25

PAUL NASH
English (1889-1946)
Das Rheingold, Scene I, 1925
Wood engraving
7.6 x 9.2 (3 x 3⅝)
Anonymous Gift
1966.6

JAMES FREDERICK O'HARA
Canadian, active America
 (1904-1980)
Storm in the Canyon
Color lithograph
48.6 x 66 (19⅛ x 26)
Gift of Ala Story
1968.35.1

JAMES FREDERICK O'HARA
Canadian, active America
 (1904-1980)
War Bonnet, ca. 1969
Color lithograph
60.3 x 45.4 (23¾ x 17⅞)
Gift of Ala Story
1971.13

JOHN PANTING
New Zealander (1940-1974)
Untitled, 1968
Serigraph (30/50)
75.3 x 75.3 (29⅝ x 29⅝)
Gift of Mrs. William Lewis Barry
1971.14

MAX PAPART
French (b. 1911)
Epreuve d'Artiste
Lithograph
49.8 x 65.4 (19⅝ x 25¾)
Gift of Margaret Mallory
1970.17.2

MAX PECHSTEIN
German (1881-1955)
Krankes Mädchen, 1918 (Sick Girl)
Woodcut
39.3 x 27.9 (15½ x 11)
Ala Story Purchase Fund
1965.27

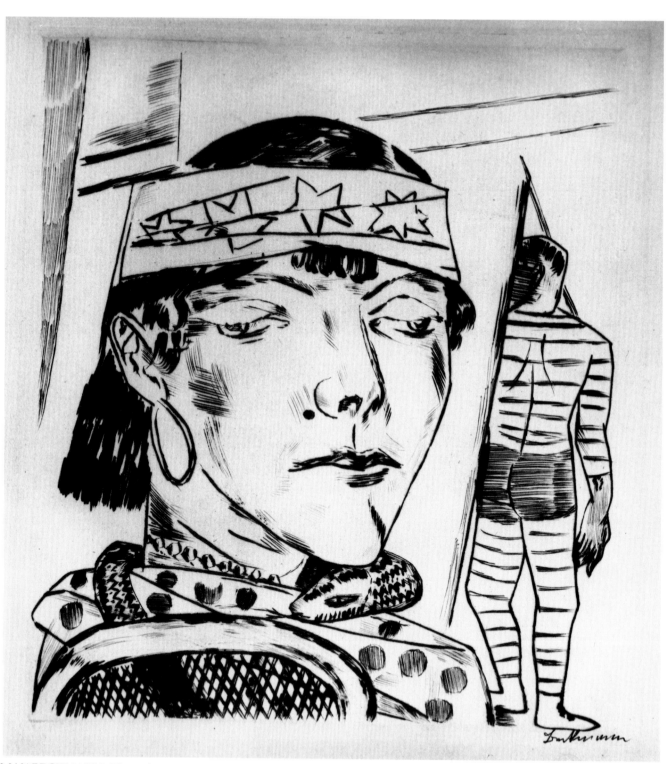

MAX BECKMANN, *The Snake Charmer*, 1921

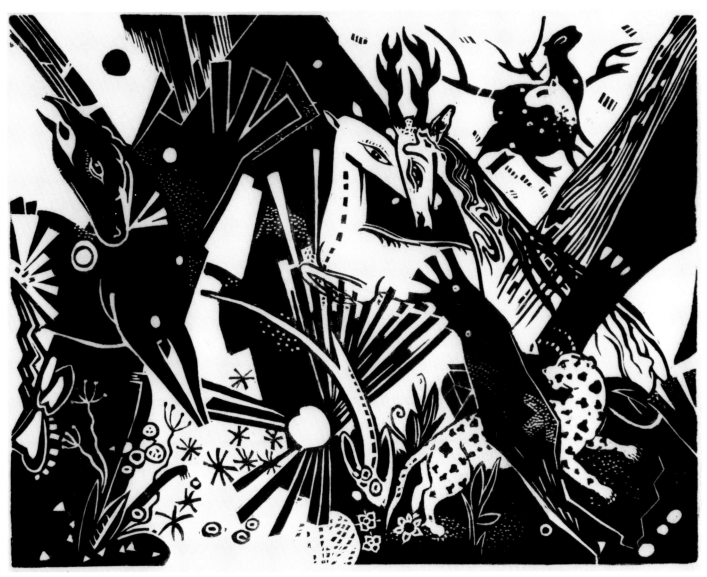

HEINRICH CAMPENDONK, *Composition with Animals*, 1916

MAN RAY
American (1890-1977)
Monument
Color lithograph (21/125)
57.7 x 45.1 (22¾ x 17¾)
Gift of Margaret Mallory
1970.17.1

GEORGE RICKEY
American (b. 1907)
Untitled, 1965
Lithograph
57.7 x 45.1 (22¾ x 17¾)
Gift of Ala Story and Margaret
 Mallory
1968.41

BEN SAKOGUCHI
American (b. 1938)
Eva J. Often Sits by Her Windows
Engraving
70.5 x 55.6 (27¾ x 21⅞)
Ala Story Purchase Fund
1966.7

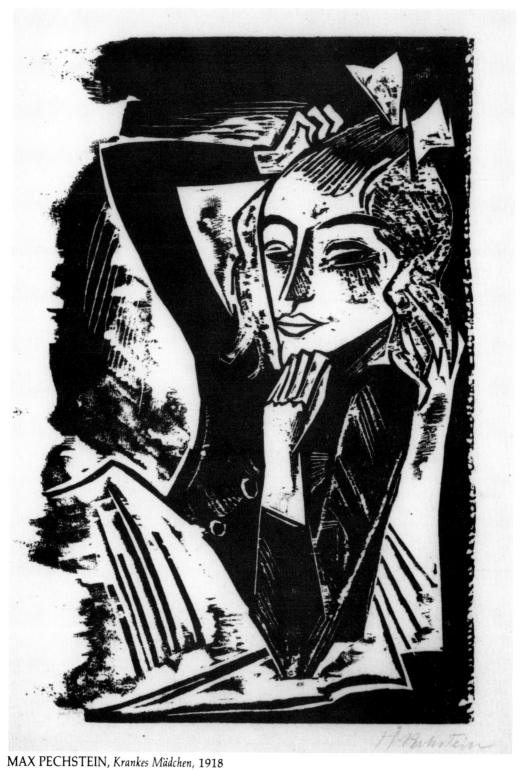

MAX PECHSTEIN, *Krankes Mädchen*, 1918

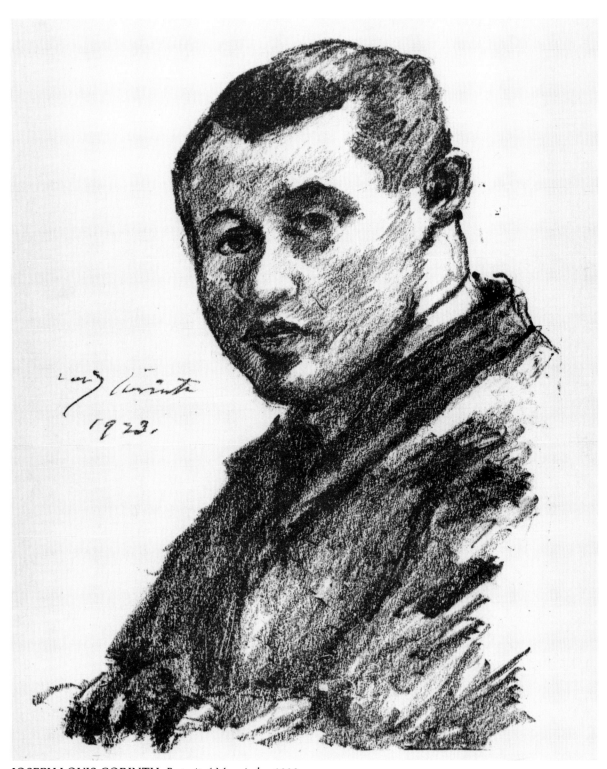

JOSEPH LOVIS CORINTH, *Portrait of Marczinsky*, 1923

JOSEPH LOVIS CORINTH, *Frau im Bett,* 1918

KARL SCHMIDT-ROTTLUFF
German (1884-1976)
The Sun, 1914
Woodcut
40 x 49.5 (15¾ x 19½)
Ala Story Purchase Fund
1965.28

WILLIAM SCOTT
Scottish (b. 1913)
Female Torso
Lithograph (32/75)
80.7 x 55 (31¾ x 21⅝)
Gift of Margaret Mallory
1973.6.5

WILLIAM SCOTT
Scottish (b. 1913)
Female Torso
Lithograph
80.7 x 55 (31¾ x 21⅝)
Gift of Margaret Mallory
1973.6.6

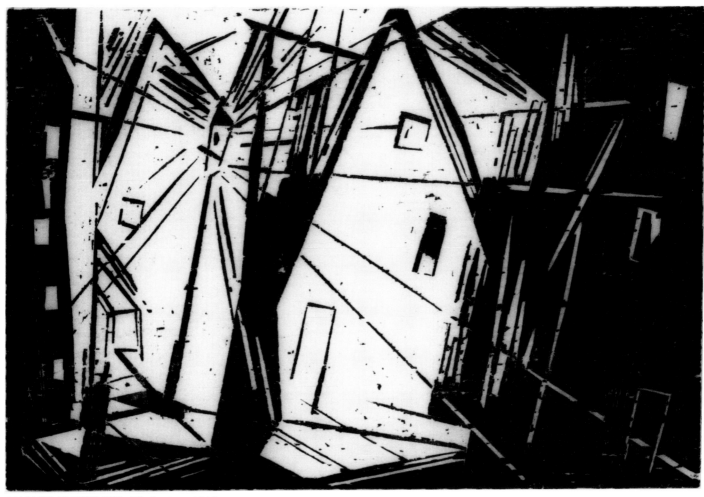

LYONEL FEININGER, *The Lantern*, 1918

BEN SHAHN
American (1898-1969)
Silent Night
Lithograph
66.6 x 51.1 (26¼ x 20⅛)
Gift of Margaret Mallory
1967.12

DAVID SIMPSON
American (b. 1928)
Rainbow, 1969
Color lithograph
30.5 x 30.5 (12 x 12)
Gift of Ala Story
1970.37.1

JOHN P. STEWART
American (b. 1945)
Sine I, 1968
Serigraph
38.1 x 61.2 (15 x 24⅛)
Gift of Mr. and Mrs. Stanley
 Sheinbaum
1969.25

JACK STUCK
American (b. 1925)
Abstraction, 1959
Serigraph-Intaglio mixed (4/20)
45.7 x 55.2 (18 x 21¾)
Gift of Margaret Mallory
1965.22

STEFAN SUBERLAK
Polish (b. 1928)
Na Jarmark 4, 1965
 (To Market)
Linoleum cut
54.3 x 70.2 (21⅝ x 27⅝)
Anonymous Gift
1971.2.2

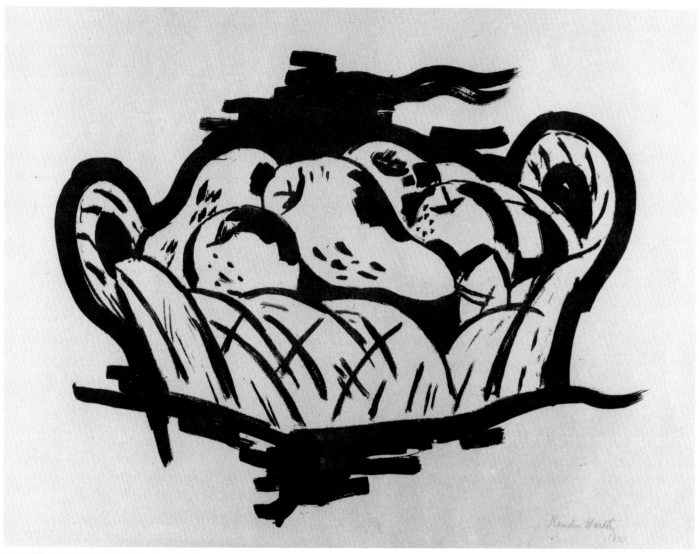

MARSDEN HARTLEY, *Pears in a Basket*, 1923

GRAHAM SUTHERLAND
English (1903-1980)
Head of Christ, 1964
Lithograph and colored chalk
21 x 17.1 (8¼ x 6¾)
Gift of English Friends in memory
 of Ala Story
1973.6.1

RUFINO TAMAYO
Mexican (b. 1899)
Woman, 1964
Color lithograph
91.5 x 66.6 (36 x 26¼)
Gift of Alice Erving
1971.9

SUZANNE VALADON
French (1865-1938)
Portrait of Utrillo, 1928
Lithograph
22.2 x 17.8 (8¾ x 7)
Gift of Margaret Mallory
1965.23

STANLEY WILLIAM HAYTER, *Combat, 1936*

ERICH HECKEL, *Young Clown*, 1930

FÉLIX VALLOTTON
Swiss (1865-1925)
Le Triomphe, 1898
Woodcut (Trial proof on cream
 woven paper, for edition of 25)
 from series "Les intimités"
25.1 x 32.4 (9⅞ x 12¾)
Promised Gift

ERNST VAN LEYDEN
Dutch, active Paris and Venice
 (b. 1892)
Untitled, 1966
Color lithograph (19/20)
76.8 x 56.5 (30¼ x 22¼)
Gift of the artist
1966.28

JUNE C. WAYNE
American (b. 1918)
Quiet One, 1950
Lithograph (5/35)
52.3 x 30.5 (20⅝ x 12)
Gift of Margaret Mallory
1965.25

MAX WEBER
Russian, active America (1881-1961)
Untitled (Figure)
Color monotype
31.7 x 14 (12½ x 5½)
Gift of Mrs. Eugene Morton
 Davidson
1971.23

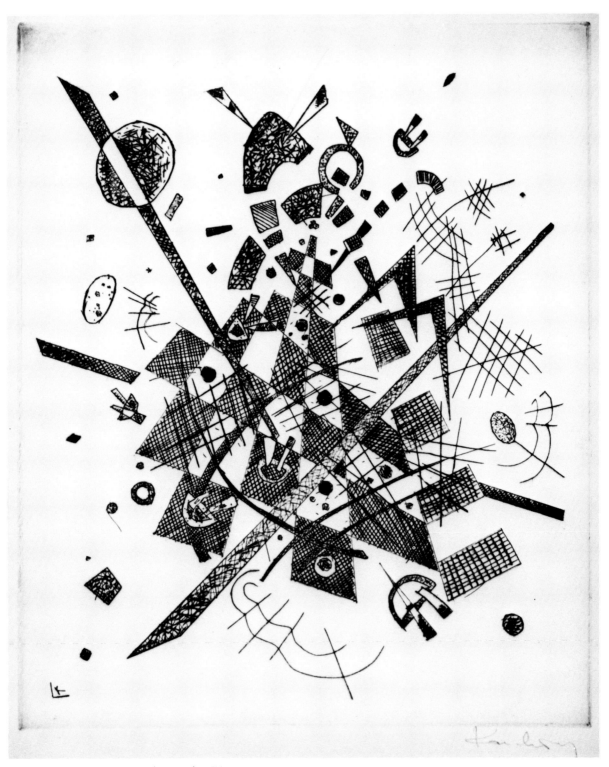

WASSILY KANDINSKY, *Kleine-Welten IX, 1922*

WILHELM VON LEHMBRUCK, *Large Head*, 1912

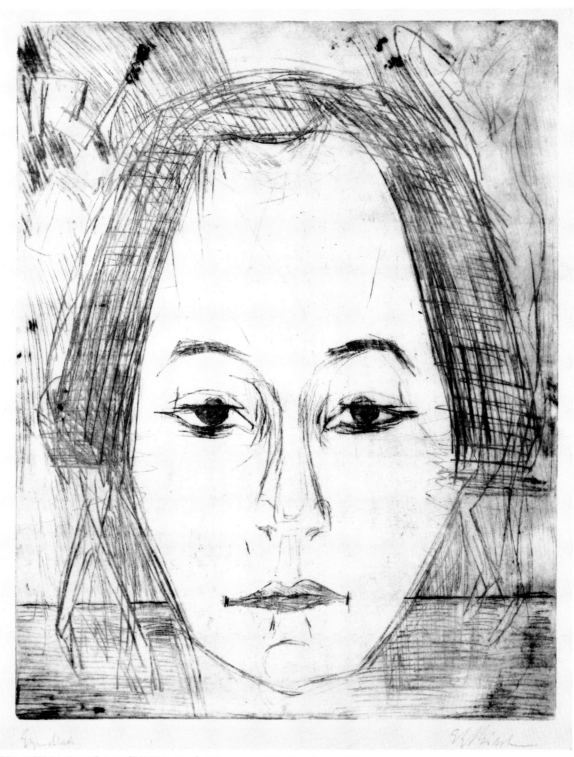

ERNEST LUDWIG KIRCHNER, *Head of the Dancer Nina Hardt*, ca. 1922

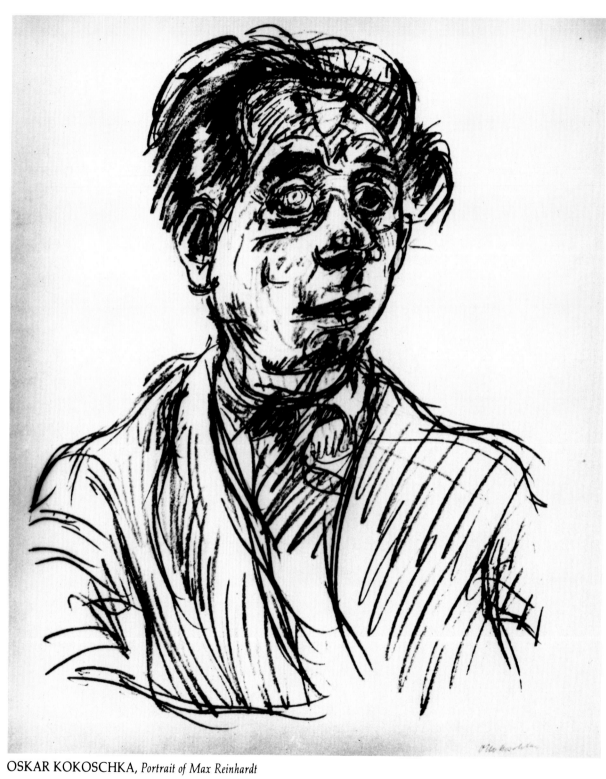

OSKAR KOKOSCHKA, *Portrait of Max Reinhardt*

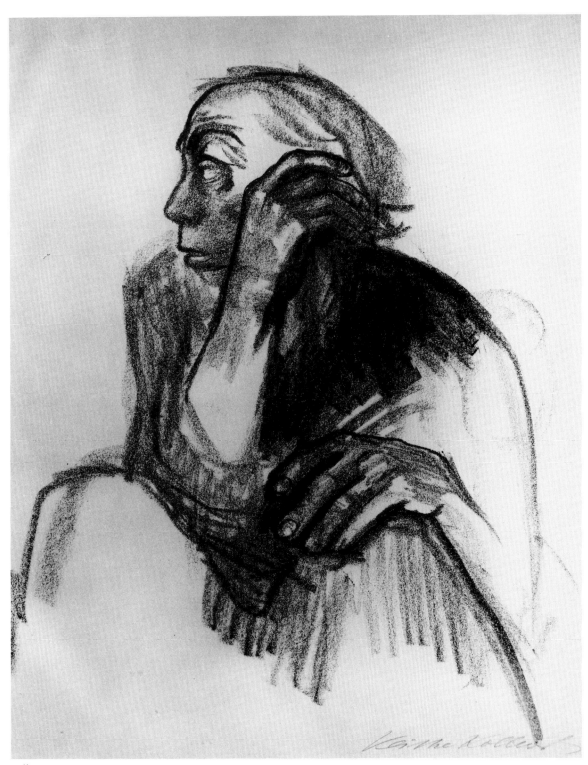

KÄTHE KOLLWITZ, *Seated Woman with Upraised Hand, 1924*

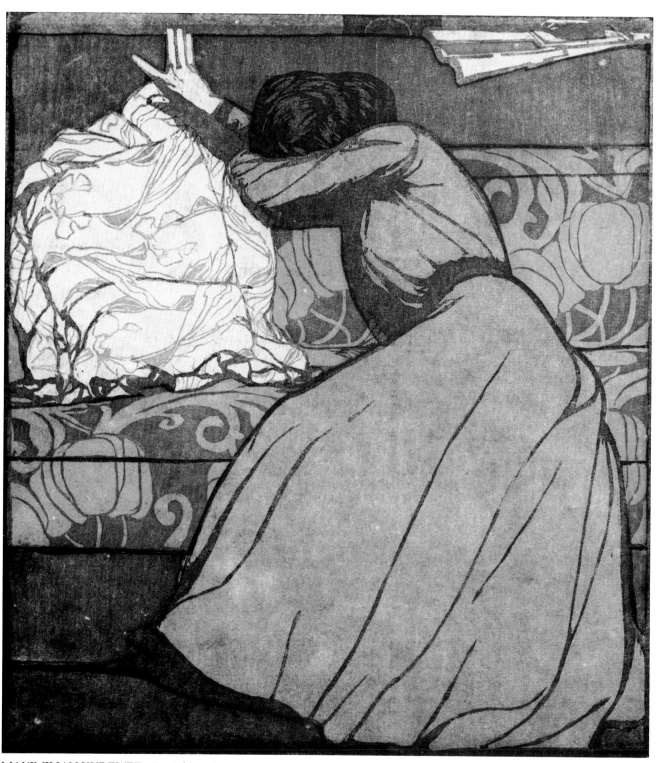

MAXIMILIAN KURZWEIL, *Der Polster*, 1903

EDVARD MUNCH, *Violin Concert*, 1903

ROCKWELL KENT, *Masthead, 1926*

PAUL NASH, *Das Rheingold, Scene I*, 1925

ROBERTO SEBASTIAN MATTA, *Untitled, 1960*

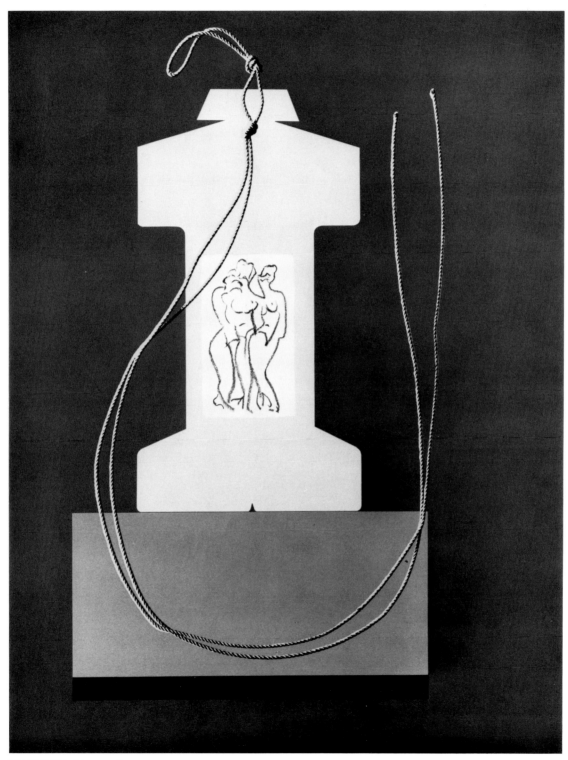

MAN RAY, *Monument*

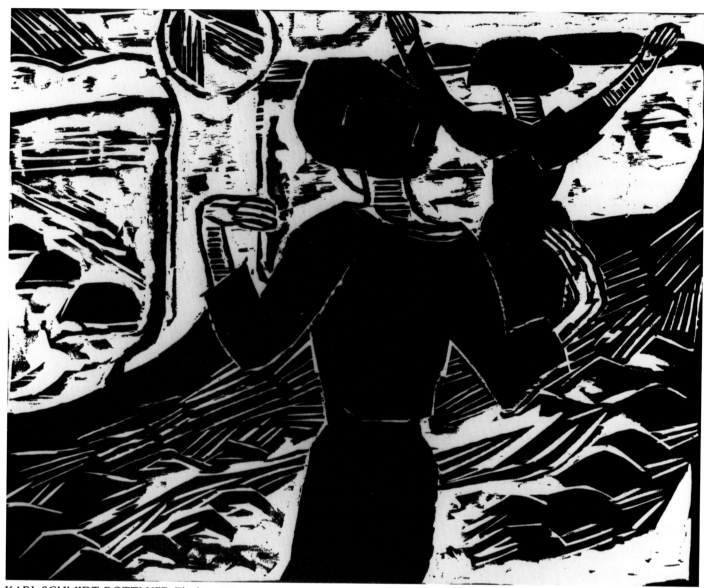

KARL SCHMIDT-ROTTLUFF, *The Sun,* 1914

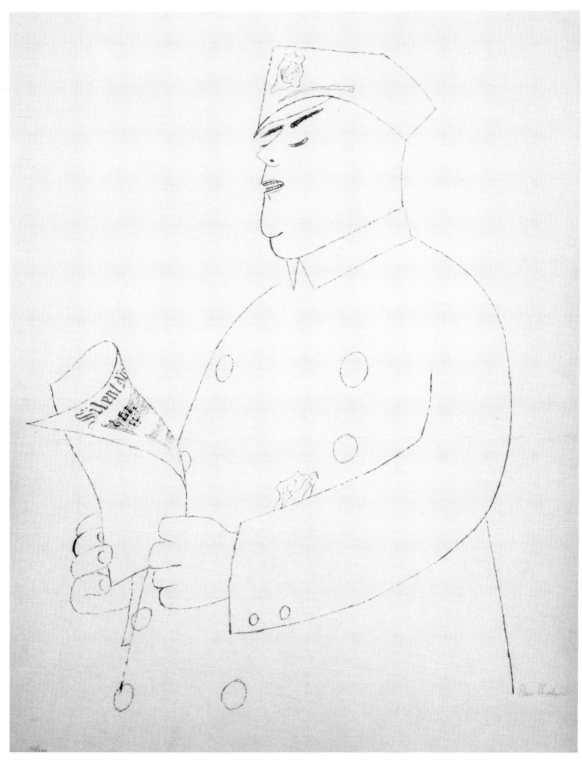

BEN SHAHN, *Silent Night*

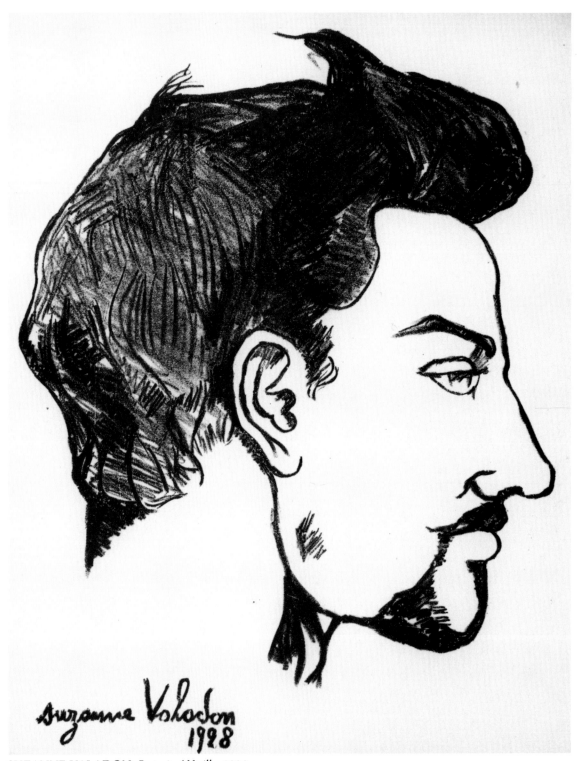

SUZANNE VALADON, *Portrait of Utrillo, 1928*

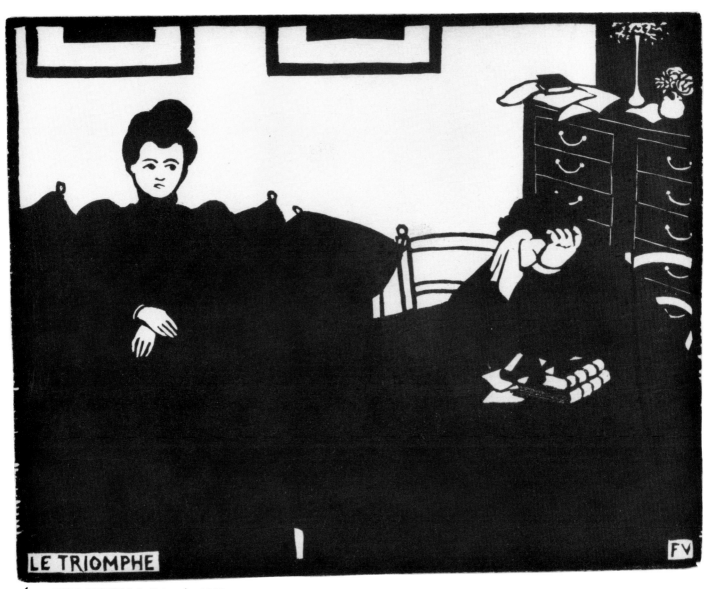

FÉLIX VALLOTTON, *Le Triomphe*, 1898

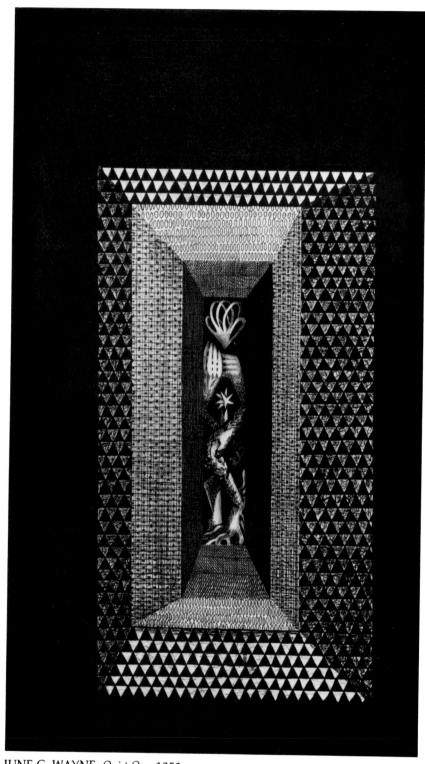

JUNE C. WAYNE, *Quiet One,* 1950

DONORS TO THE COLLECTION

This collection was made possible by the following donors as well as by those who wish to remain anonymous.

Mercedes de Acosta
Erica Anderson
Dr. and Mrs. Eugene Anderson
Alice Baber
Mrs. William Lewis Barry
Mrs. Donald Bear
Dorothy Brown
William Brown
Hans Burckhardt
Chalifoux Purchase Fund
Mr. and Mrs. Hugh Chisholm, Jr.
Mrs. Eugene Morton Davidson
William Dole
English Friends in memory
 of Ala Story
Alice Erving
Dr. Beatrice Farwell

Mr. and Mrs. Howard Fenton
Jack Gage
Mr. and Mrs. David Gensburg
Hanover Gallery, London
Katherine Harvey
Diana Heiskell
Veronica Helfensteller
Dr. and Mrs. MacKinley Helm
Olga Ivanjiki
Ernst van Leyden
Robert M. Light
Wright S. Ludington
Phyllis Lutyens
Mrs. Clifford D. Mallory
Margaret Mallory
Dr. Toni Marcy
Maxwell Galleries
Fred Maxwell

Margaret McLennan Morse
Lee Mullican
Michael O'Shaughnessy
Frank Perls
Marion Pike
Redfern Gallery, London
Esther and Robert Robles
Mr. and Mrs. Joseph Halle Schaffner
Mr. and Mrs. Stanley Sheinbaum
Walter G. Silva
Mrs. John W. Stewart
Ala Story
Ala Story Purchase Fund
F. Bailey Vanderhoef, Jr.
Mason B. Wells
Beatrice Wood
Jacob Zeitlin

BOARD OF TRUSTEES